Noovo Volume 2: Fashion with Soul

contents
& colophon

Fashion with Soul

Noovo Editions is an independent editorial and cultural project by María del Rosario González y Santeiro and Jorge Margolles Garrote with online and paper editions. Noovo seeks to be an aesthetic arbiter and a cultural mediator at the juncture between Fashion, Photography and Jewellery: a platform to show the highest level of creativity from around the world.

www.noovoeditions.com

Noovo paper editions are published by
The Pepin Press BV
P.O. Box 10349
1001 EH Amsterdam, The Netherlands
mail@pepinpress.com

www.pepinpress.com

Noovo volume 2: Fashion with Soul
ISBN 978 90 5496 164 2

Fashion editor
María del Rosario González y Santeiro

Photography editor
Jorge Margolles Garrote

Publisher
Pepin van Roojen

Copy editor
Ruth Styles

This book is produced by The Pepin Press
in Amsterdam and Singapore.

Printed and bound in Singapore

Whether you like it or not, fashion is part of our existence, even unconsciously. In these times of fast-paced communication, the media message tends towards the globalisation of thoughts. It subtly yet resoundingly homogenises our perception of the ever-fascinating and seductive world of fashion. Brands, trends, catwalk shows, magazines, fairs, chains, department stores and, of course, advertising have all contributed to the creation of a complete web of reference points spread by the mass media.

NOOVO offers a vision of fashion in its most strikingly creative facets. It shows an entire diverse, multicultural universe of creativity, in complete and utter independence from all established systems. The designers chosen (both established and upcoming) are able to express their vision, ideas and thoughts through personal texts and extraordinary images. Together, they give insight into today's world of cutting-edge fashion.

NOOVO has inquired into the limits of what is out there, trying to find 'fashion with soul'. Since 2005, NOOVO has passionately sought out the least conventional ways to spread the most prolific work and thoughts in fashion. NOOVO strives to consolidate radical, modern and timeless fashion creations from a unique, contemporary perspective with a strong focus on the talents of its creators. It is a platform for designers to showcase their work in a way that withstands the erosion of time.

bag designer

Isaac Reina

http://www.isaacreina.com

Isaac Reina was born in Barcelona in 1968 and later studied architecture and fashion. His debut collection, *Isaac Reina: Edition de sacs*, was launched in 2006 and his first boutique opened in Paris in the same year. He has worked with Quai de Valmy, Maison Martin Margiela and Limoland among others.

'I make very simple pieces; they are unpretentious and normal. All have industrial or commercial shapes but are crafted by hand. Quality is my priority. Beautiful materials, good craftsmanship and correct proportions are elementary principles but are too often forgotten. These are the only details I need. The hard part is simplifying the design over and over again. You could say my work has a no design concept: it's almost invisible, a simple thing such as taking time to get some rest or a breath of fresh air. There's no innovation, no special effects. Just the essentials: function and a natural, unsophisticated beauty. My inspirations? Industrial aesthetics, basic packaging, die cutting and paperboard folding. In terms of people, I look up to Arne Jacobsen, Charlotte Perriand, Jonathan Ive and Jasper Morrison.'

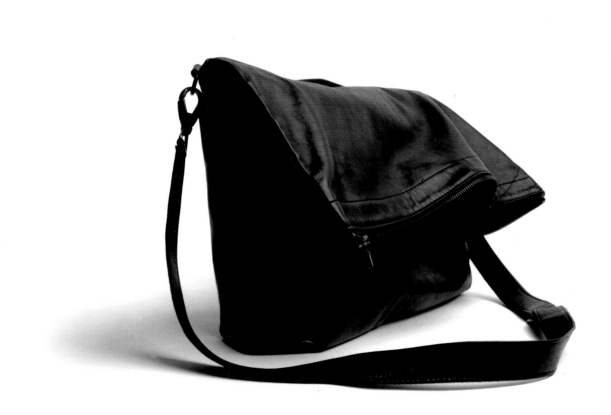

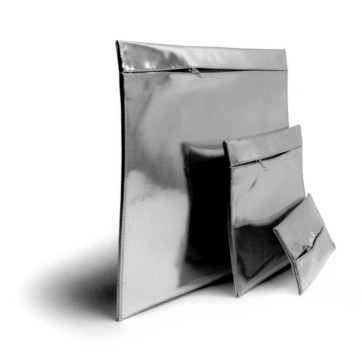

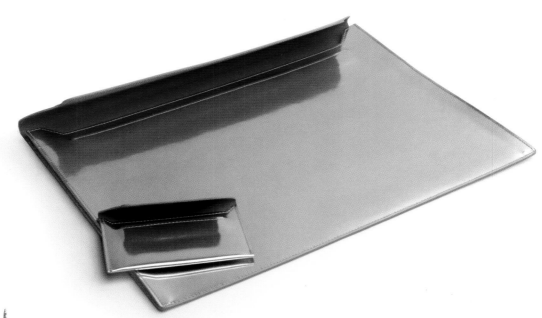

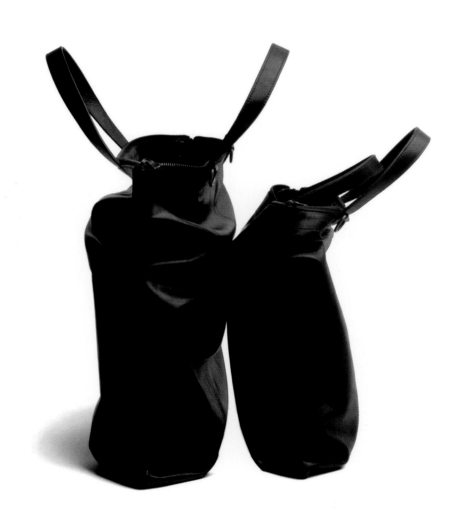

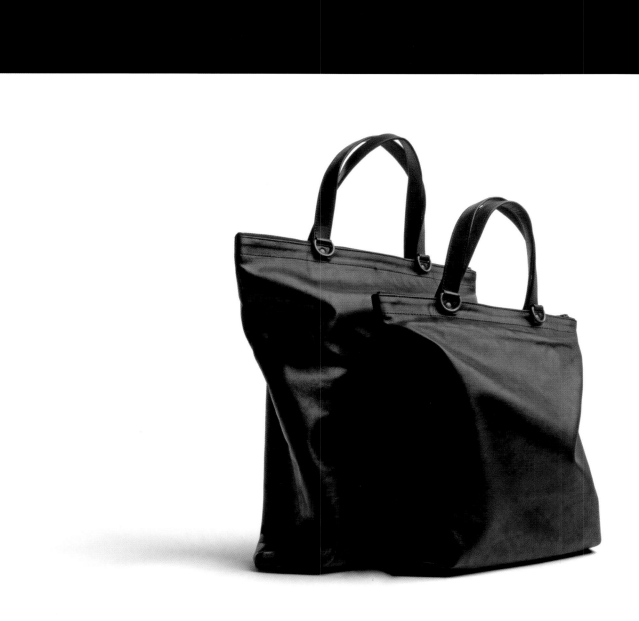

bag designer

Marc Marmel

http://www.marcmarmel.com

Marc Marmel is a Los Angeles based luxury leather goods company that takes pride in handcrafting its products in the USA. It is available at Barneys New York and at marcmarmel.com

There was a time when travel was about the journey, not the destination. A time when custom-made luggage was a privilege enjoyed only by the wealthy. A time when luggage journeyed to exotic locations by carriage, train or steamship. While on holiday in the French Riviera, Marc Marmel realised that there were people who travelled the world but who yearned for the glamour of the golden age of travel in the 1920s and 30s. One should not have to forsake luxury and style for practicality and mobility. Inspired by vintage pieces by Louis Vuitton, Goyard and Hermès, Marc created an exclusive line of handmade luggage with modern travellers in mind.

The concept is simple: leather that looks old and well-travelled but isn't. You don't have to worry about scratches and scuffs. Like an oyster, the exterior is rough but instead of a pearl, inside, you will find a lining of beautiful, brightly-coloured silk brocade. The Marc Marmel collection harks back to an era when travel was about the experience. Each piece looks as if you discovered it in your grandmother's attic and has hundreds of stories to tell. They speak of stylish voyages past and of the many adventures yet to come.

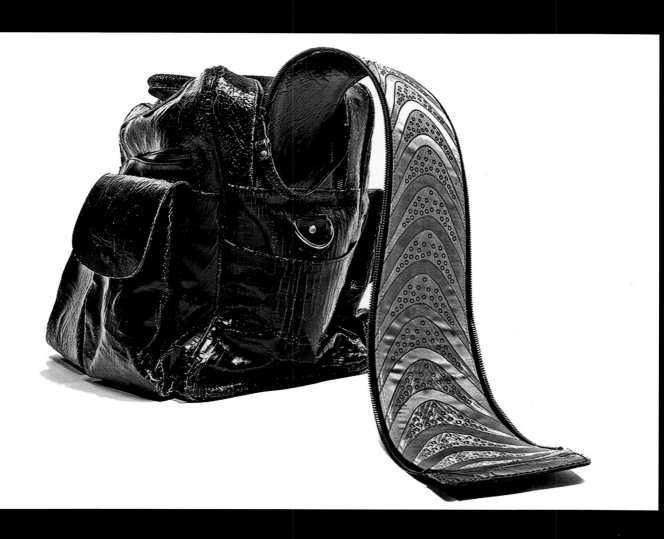

Marc Marmel The Klondike

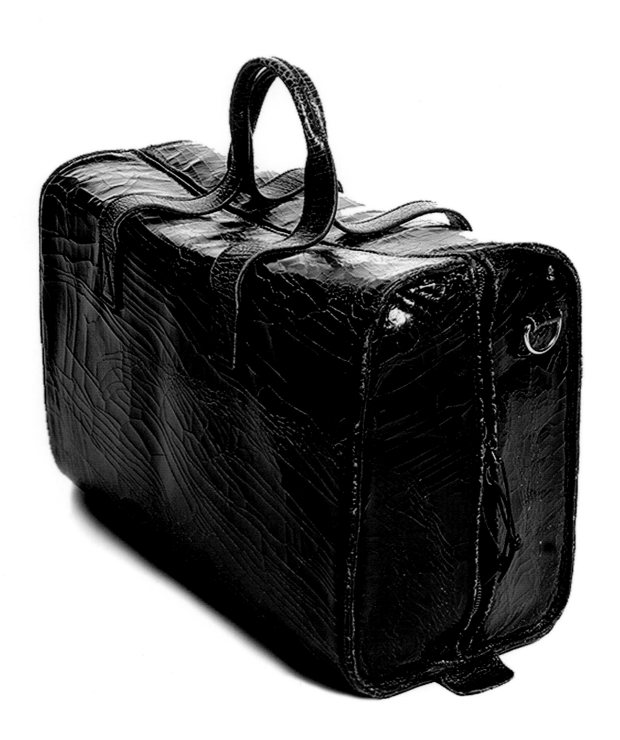

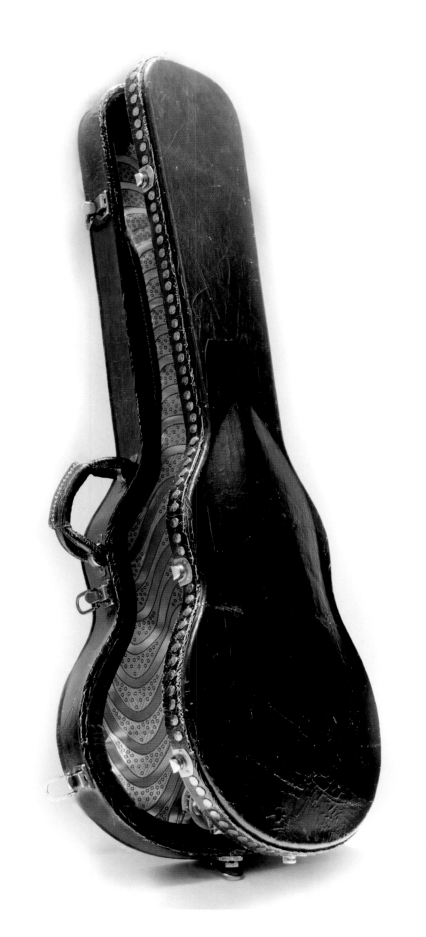

bag designer

Michaël Verheyden

http://www.michaelverheyden.be

Michaël Verheyden is a Belgian designer. Passionate about rock music but also inspired by silence, he creates fashion accessories and home objects.

In 2002 he started his own company producing leather bags and accessories. He also uses leather in his recently launched home collection, alongside solid wood, marble and linen. He prefers durable materials that feel natural and age beautifully. In addition to his love of good quality fabrics, Michaël Verheyden puts a lot of time into finding new ways to construct things. He tries to combine innovation, craftsmanship and quality, and produce clean, pure designs.

Before starting his own label, he studied industrial design and worked alongside fellow designers, including Raf Simons. Simons worked with Michaël Verheyden on his graduation project and later commissioned a series of leather bags for his summer 2003 collection. In 2009, Michaël Verheyden received the Henry Van de Velde Young Talent Award, an important mark of recognition from the Flemish design industry. Although he focuses on producing his accessories and home collection, Michaël Verheyden also creates art installations, organises exhibitions, and designs interiors and furniture.

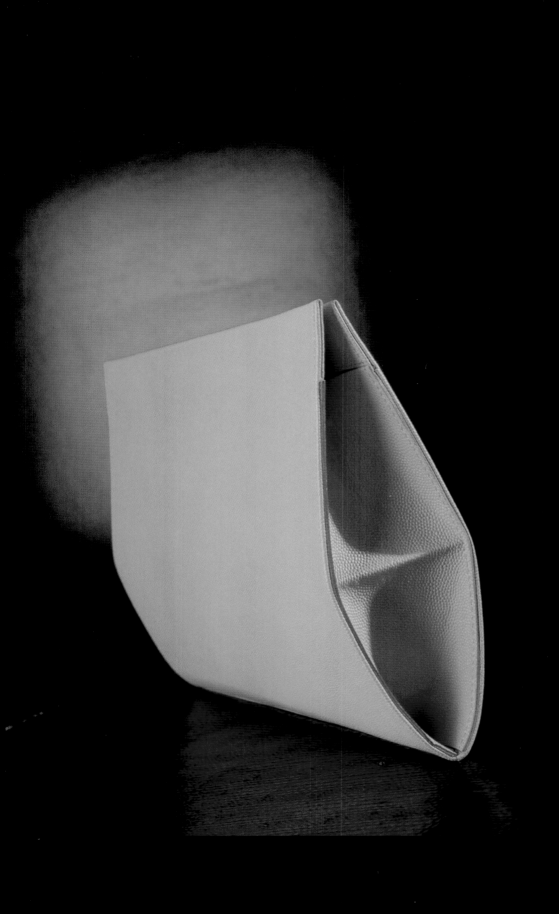

Michaël Verheyden Audriette, goat fluo orange

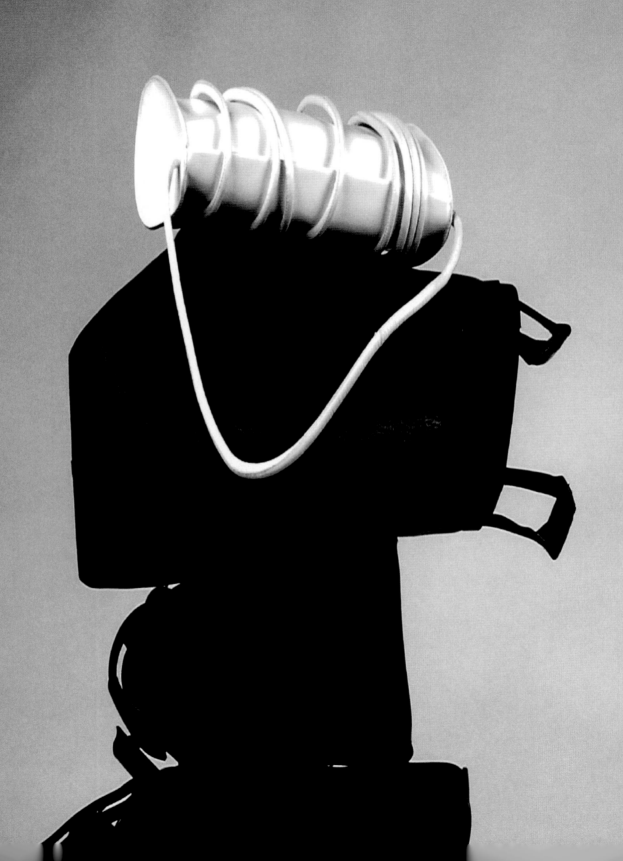

bag designer

Natalia Brilli

http://www.nataliabrilli.fr

Born in Belgium, Natalia Brilli now lives and works in Paris. A graduate of Brussels' prestigious *École de La Cambre*, she combined fashion with a career in theatrical set and costume design before going on to study at the IFM (French Fashion Institute). Following collaborations with a number of established designers, she decided to switch focus to accessories.

Success came quickly and her 2004 debut collection was picked up by several high end boutiques, including Maria Luisa, Browns and Barneys. The same year she also joined fashion house Rochas as an accessories stylist alongside creative director Olivier Theyskens. At the same time, she continued to work on her own highly-regarded line and was awarded the A.N.D.A.M. prize in 2006. Since then, she has collaborated with a number of renowned leather goods houses, most recently the acclaimed Belgian brand Delvaux.

From the outset, Natalia Brilli has been known for her unique style: necklaces created from oversized beads and cameos swaddled in the finest glove-maker's leather. Instantly recognisable, her women's and unisex jewellery lines have reworked the codes of classic jewellery. Her work has an ethereal simplicity and reassesses monochrome and surface effects.

More than a jewellery designer, Natalia Brilli has adapted her unique technique to other accessories including bags and leather goods. She is now developing an artistic line of pieces, freed from functional restraints, beginning with the 'Rockband' installation, initially created as a window display for Parisian boutique Maria Luisa.

Her cultivated elegance and flexible aesthetic can be seen in her latest series based on animal skulls. Transcending the grisly aspect of these hunting trophies, she brings them a new dimension by encasing them in leather, stressing contours and deep detailing, and elevating them to the status of art.

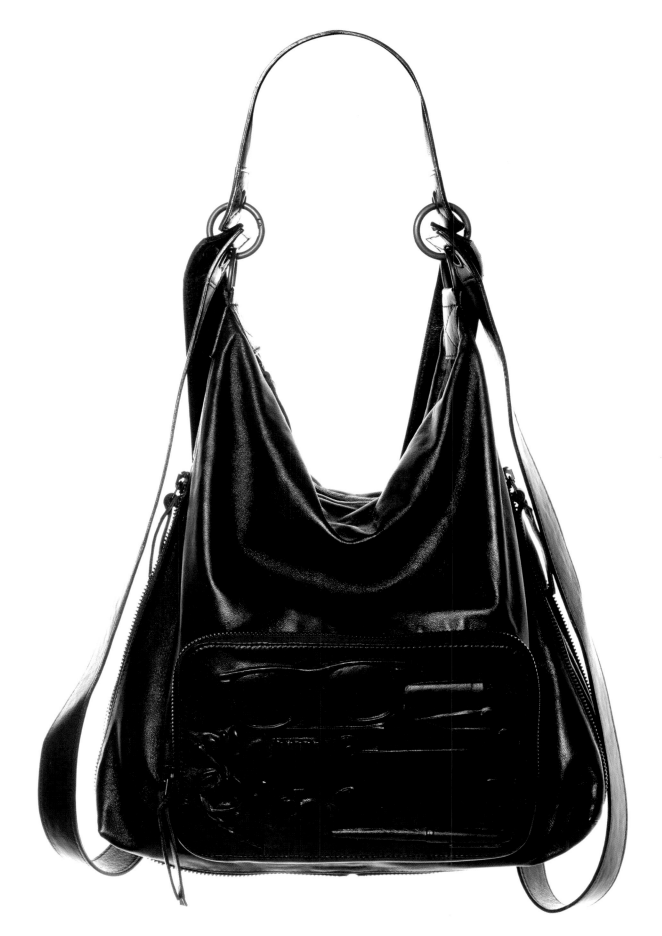

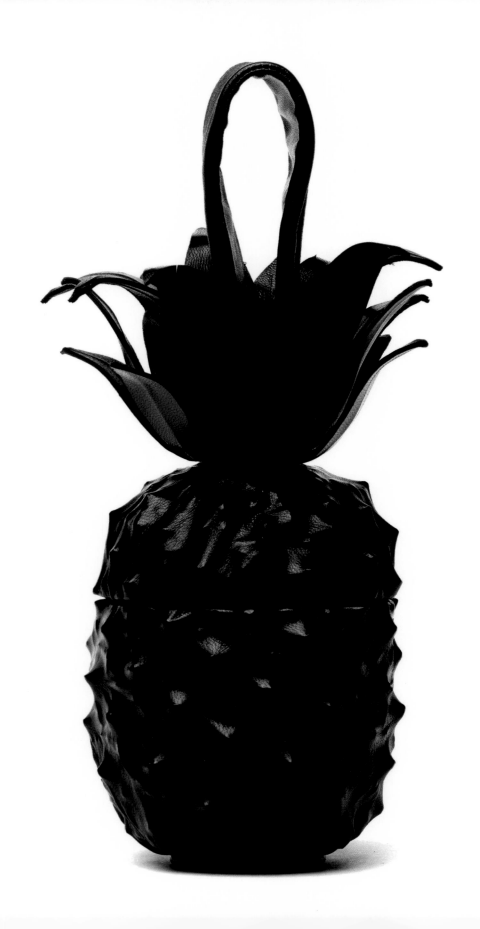

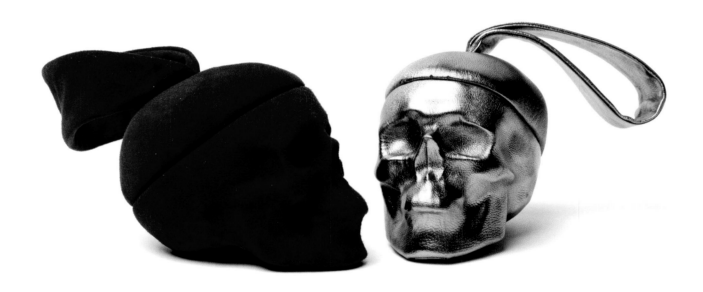

bag designer

Rachel Esswood

http://www.rachelesswood.com

Based in London and New York, accessories designer, Rachel Esswood, is challenging traditional interpretations of the male form to create pieces that offer something different to the modern man. A graduate with a first class honours degree from Cordwainers at the London College of Fashion, her latest collection The Cell of Virility, is for men who have a daring nature, are insatiably experimental and exude a bold confidence.

Esswood's career began with the Jacobson Group in Manchester, where she completed a year's apprenticeship designing for Gola Classics in addition to creating non-branded products for commercial high street retailers. Esswood also gained experience with Mulberry and Temperley London. Upon graduating, Esswood was awarded The Curriers' Travel Scholarship at the London College of Fashion Awards Ceremony 2009. Esswood's unique vision for experimental, innovative products also led to her winning two competitions: the accessory category at the ASOS Ltd. 100 2009 in London and the Independent Handbag Designer Awards 2009 in New York. These awards gave her the chance to work with luxury design house Devi Kroell in New York and see her pieces sold online at asos.com. These achievements, plus freelance design opportunities, features in a number of publications, including *Vogue.com*, have resulted in Esswood

being acclaimed as one of London's best up-and-coming creative talents.

Esswood was exposed to a variety of different arts from an early age and acquired an appreciation and understanding of classical music. She regularly attended concerts, opera and dance performances; the influence of which can still be seen in her work today. Esswood believes that each step within the design process is of great importance, and must display a clear visionary concept. Her passion for dramatic costume and the desire to create a visual narrative through design, continue to be the main references within her work. The collection The Cell of Virility is manifested through a number of forms and focuses on accessorising with a clean and refined design, via innovative construction techniques using leather and yarn.

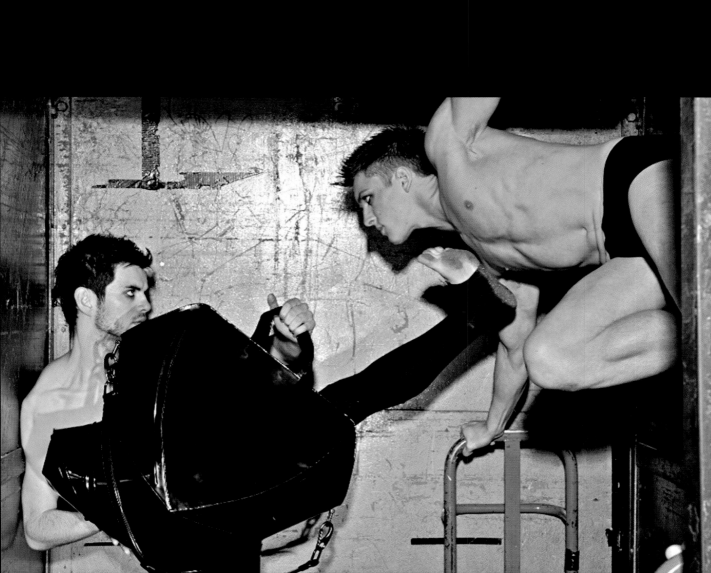

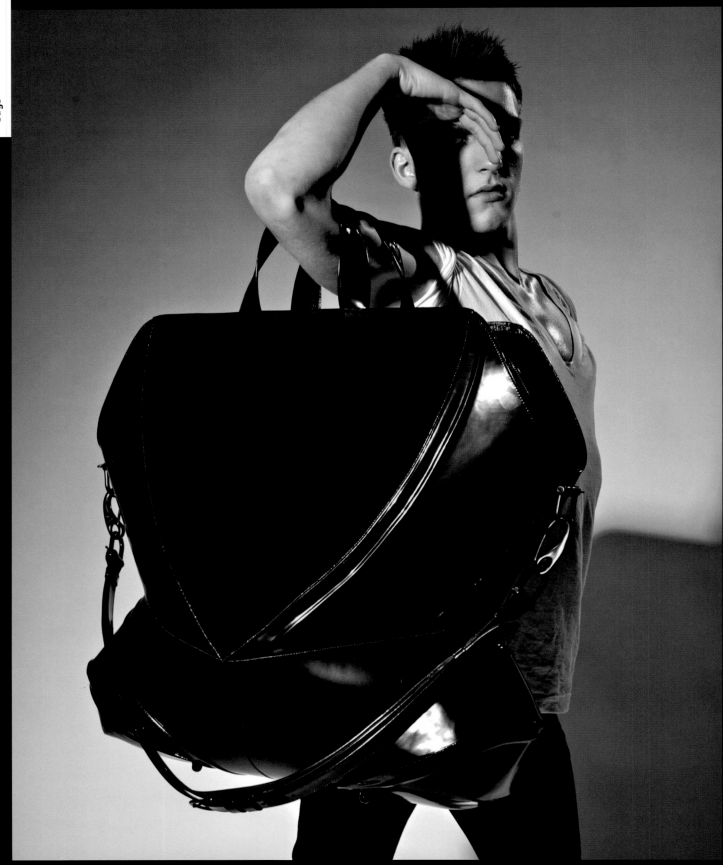

Rachel Esswood

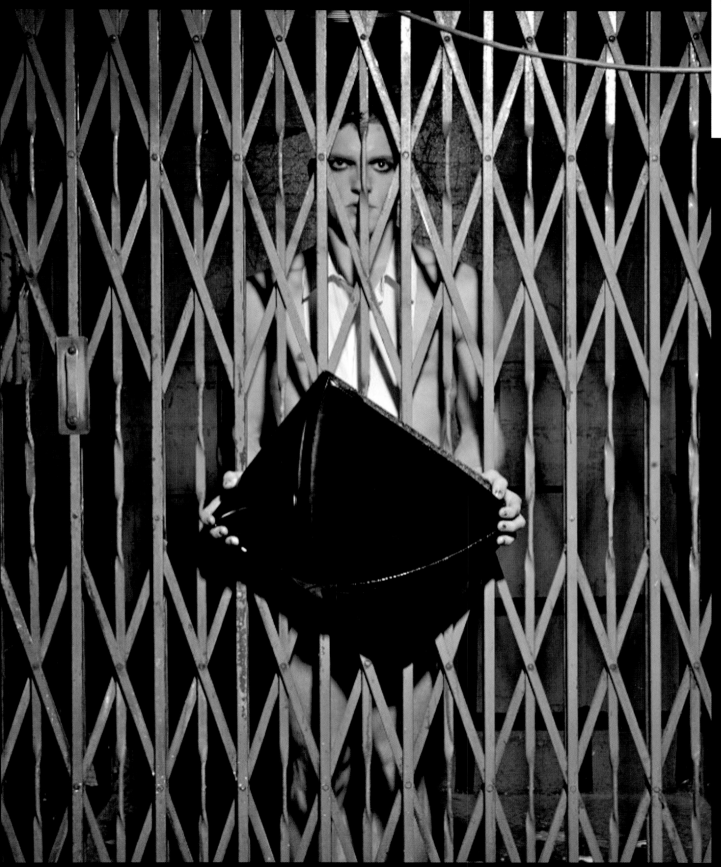

Rachel Esswood

bag designer

Timmy Woods

http://www.timmywoods.com

Designer Timmy Woods launched Timmy Woods of Beverly Hills in 1992, drawing on years of experience in the arts, design and business to create a line of handbags inspired by fashion, high art, nature, sports, pop trends and holidays. A native of Beverly Hills, Woods travelled extensively as a teenager.

The holder of a degree in sociology and art from UCLA, she later attended The Fashion Institute of Design and Merchandising in New York, before pursuing her studies at the University of Singapore. She has also worked as a model and classical ballet dancer with The New York City Ballet, performing in shows such as The Nutcracker.

Timmy Woods' debut collection of bags immediately attracted the attention of Bergdorf Goodman, Bendel's and Bloomingdale's. As her business grew, she was offered, and accepted, a position designing at Ken Done for the U.S.A and B.J. Designs. Later, her extensive network of contacts, expertise in design and knowledge of the Pacific Rim led to a successful stint in international property sales but her heart remained in the design world. In 1992 she came across some hand-carved wooden boxes in a Filipino market. This inspired her to return to her first love, design, and she launched Timmy Woods of Beverly Hills later the same year.

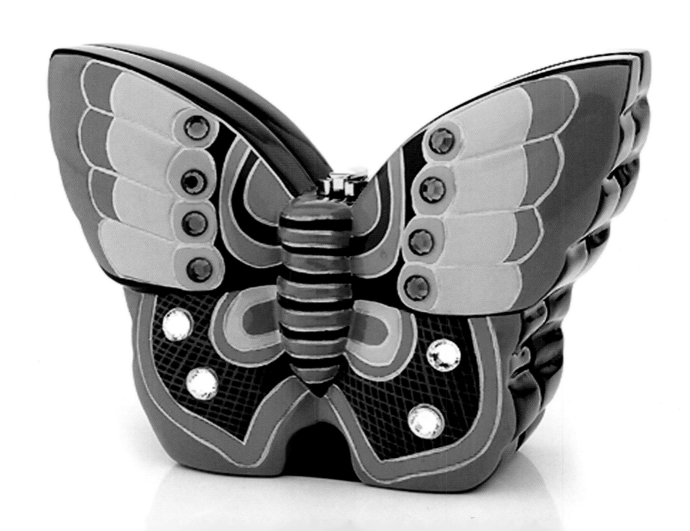

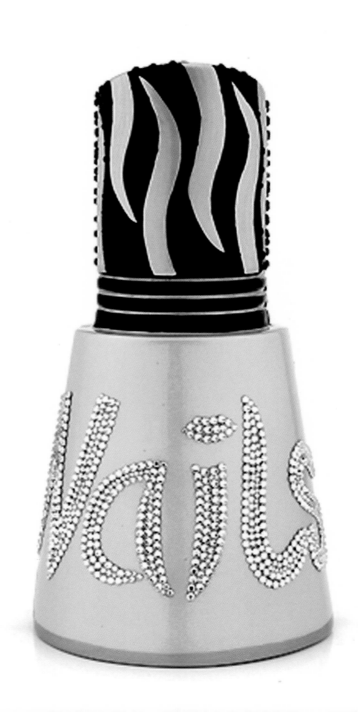

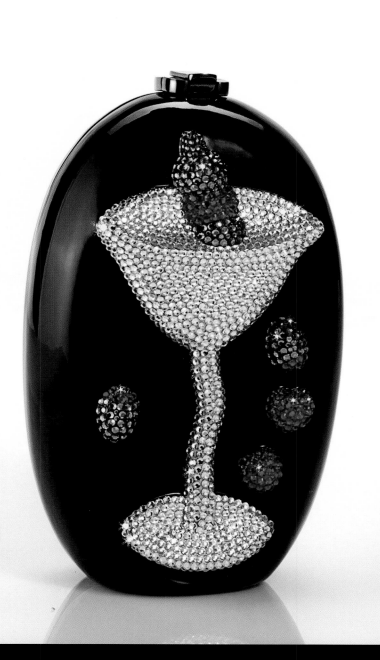

Timmy Woods Cheers fully stoned

bag designer

Wendy Stevens

http://wendystevens.com

'The two decades I have spent making and marketing my handbags have only increased my commitment to and passion for my work. I began designing in 1983 in New York, where I drew inspiration from the industrial materials that I saw in the city every day. Working with a circle of artistic friends, I began to develop an original, unique style which resulted in the modern, durable and versatile accessories I create today.'

All the handbags are made of stainless steel with leather and metal components, and are hand crafted. The use of stainless steel as the primary material has given strength, form and longevity to the product. When paired with leather elements, the handbags become user-friendly and ultra functional. Maintaining quality and precision in the production of each piece is crucial. As the handbag collection evolves, the possibilities for creating new models with diverse shapes, sizes and textures seem limitless.

The handbags have been marketed through three types of domestic and international trade show venues: fashion, design and craft. Stores that best represent the work are luxury fashion boutiques such as Takashimaya in NYC and museum shops such as the Museum of Contemporary Art in Chicago. New international venues are currently being explored in Europe and Canada as those markets appreciate quality, the unique use of materials and the original design of the handbags.

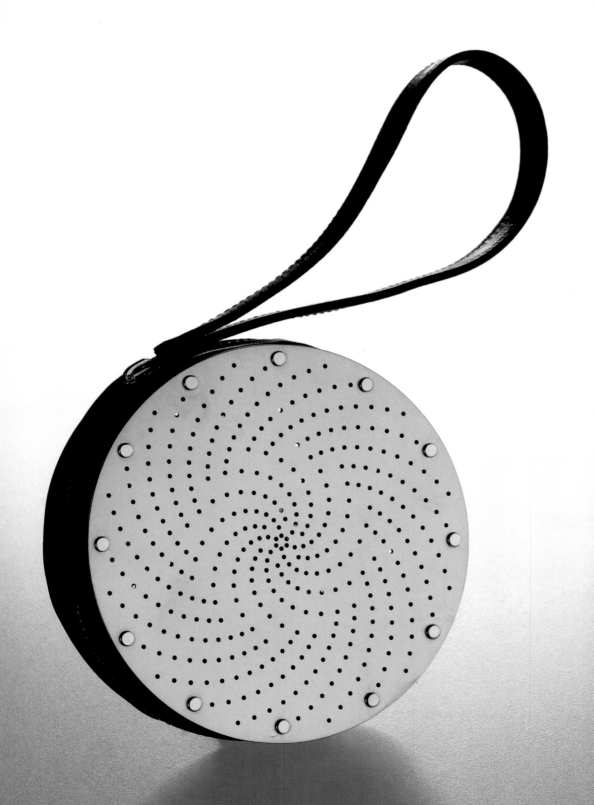

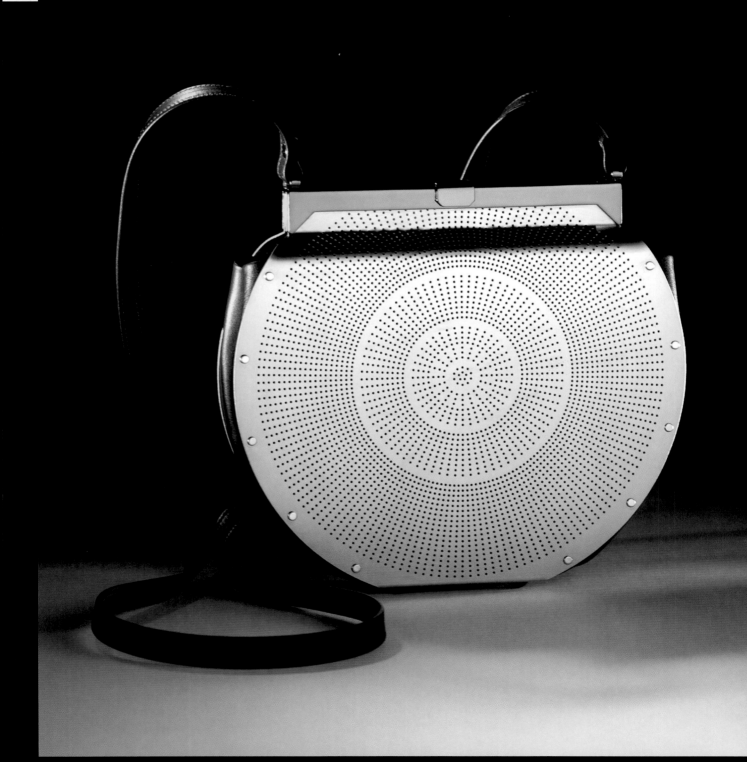

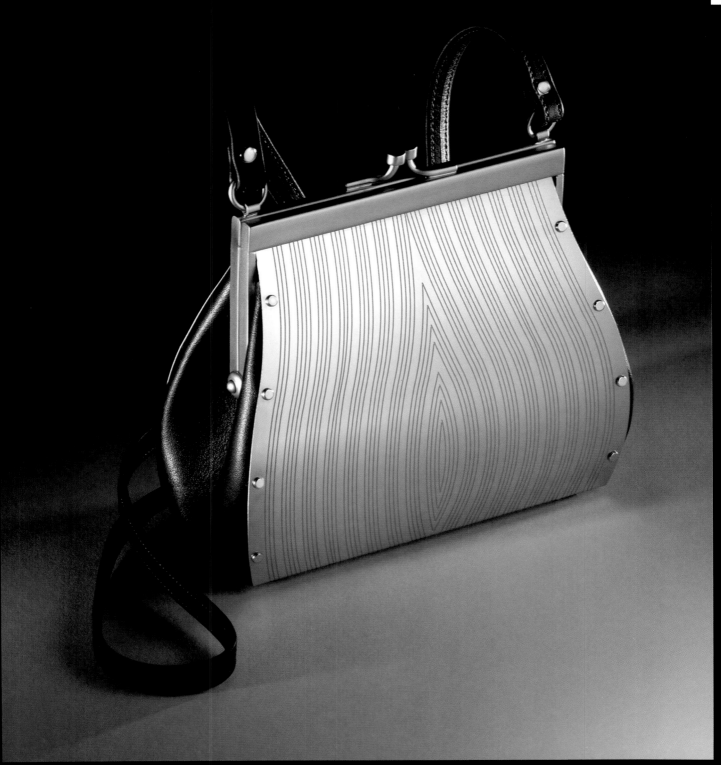

Wendy Stevens

fashion designer

Aguri Sagimori

http://www.vantan.com/agurisagimori

Born in 1985 in Neyagawa City, Osaka, Aguri Sagimori graduated from the Vantan Design Institute of Fashion in 2007. The same year she won the New Designer Fashion Grand Prix in Nagoya. She made her debut at Japan Fashion Week in March 2008 and later participated in the 2009 Vantan Tokyo group exhibition at Paris Fashion Week, showing her fourth collection. Her work is a combination of high concept design and edgy cuts which allow her to fuse modern techniques with classic style.

Her first collection combined an homage to Alfred Hitchcock's *The Birds* with classic design to produce high concept pieces. For her SS10 collection, she showed a more representative style: minimal and sharp with the jackets created using men's tailoring techniques in fabrics such as fine wool, vintage satin, linen and leather. Her latest collection was inspired by a dream of beauty seen inside a moment. Delicate fabrics such as satin and tulle are edged with leather to create a single piece garment with a restrained silhouette. Her collection is defined by three dimensional, uneven expression, visible in the coarse handmade knits, leather details and boar leather accents.

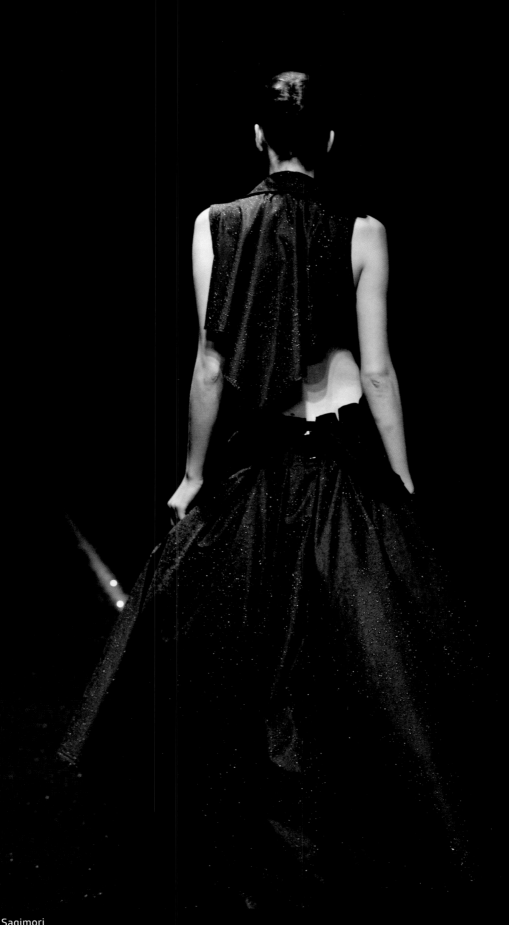

Aguri Sagimori

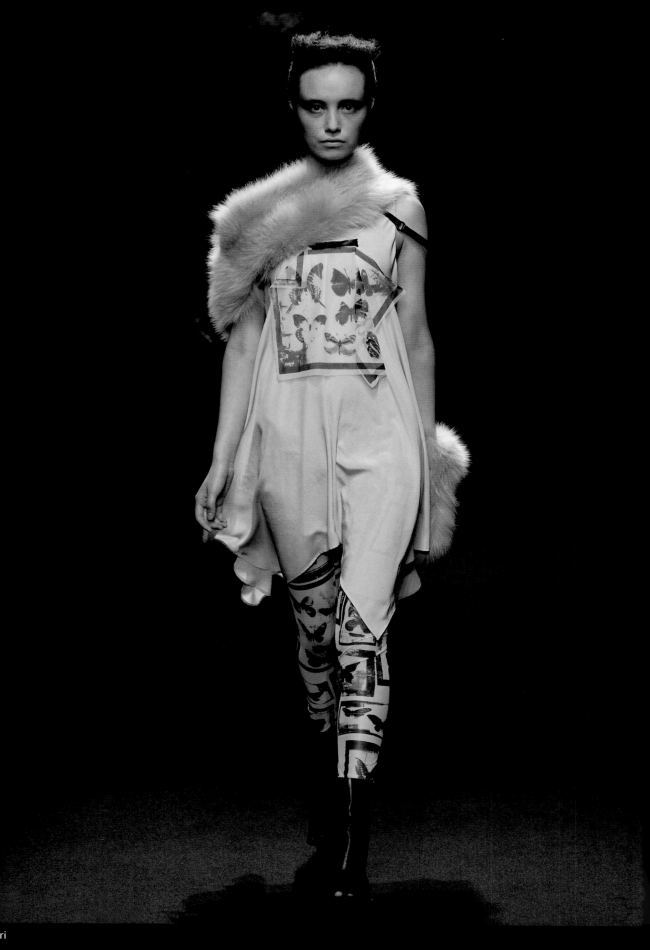

Aguri Sagimori

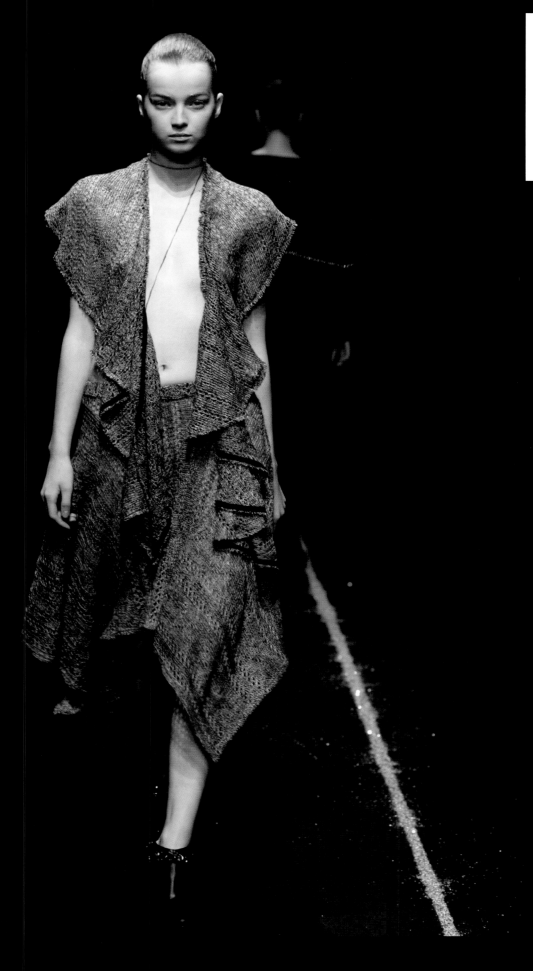

Aguri Sagimori

fashion designer

Asher Levine

http://www.asherlevine.com

The fashion magazine *Noovo* has a powerful word in its mission statement: disassociation. A central part of my design philosophy orbits around this word: I disassociate myself from fashion design through being inspired by things like particle physics, biological abnormalities, grotesque visuals and beautiful works of art, to name just a few. I think it's important to disassociate yourself from your own work, to bring it to the next level and to create fresh, new pieces for humanity. It's the only way we can evolve.

For my latest collection, I wanted to offer men new choices of silhouette by fusing fluidity with structure. Incorporating draped pieces with cropped leather jackets makes the male form sexier. I also changed the body's proportions by building volume in the jeans and jacket styles for an edgier look but offset it with drapery, offering the wearer the ability to snap the drape into place to create a completely different, subtler look. I'm obsessed with animal skins too, so for the vest style, I combined emu, broadtail, and fox, which yielded a fluid body with a structural neck, creating a sexy image overall.

I've been sewing since I was 10 years old; fashion just seems to be a part of my being. Every day I research media that disassociates me from the craft I love, but it's the only way to take my work to a new level.

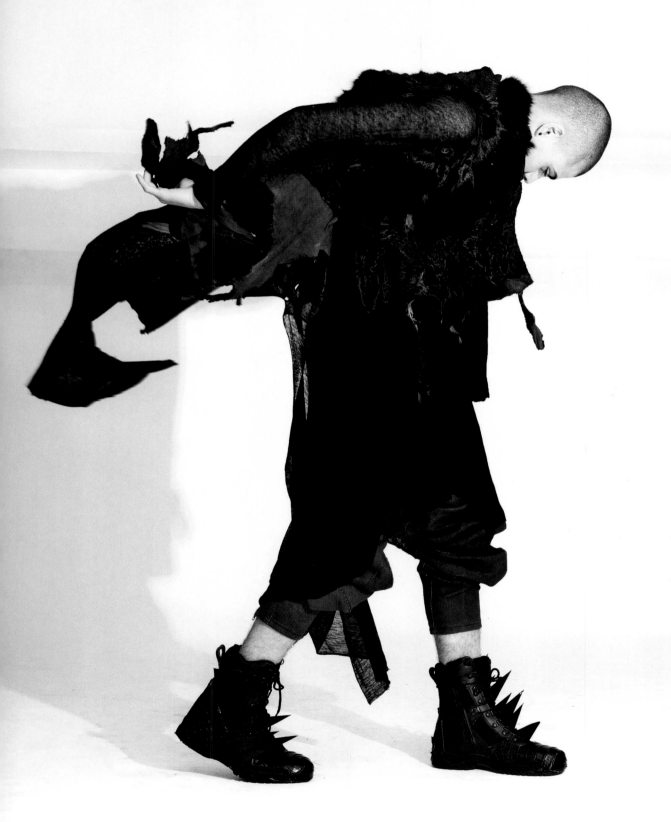

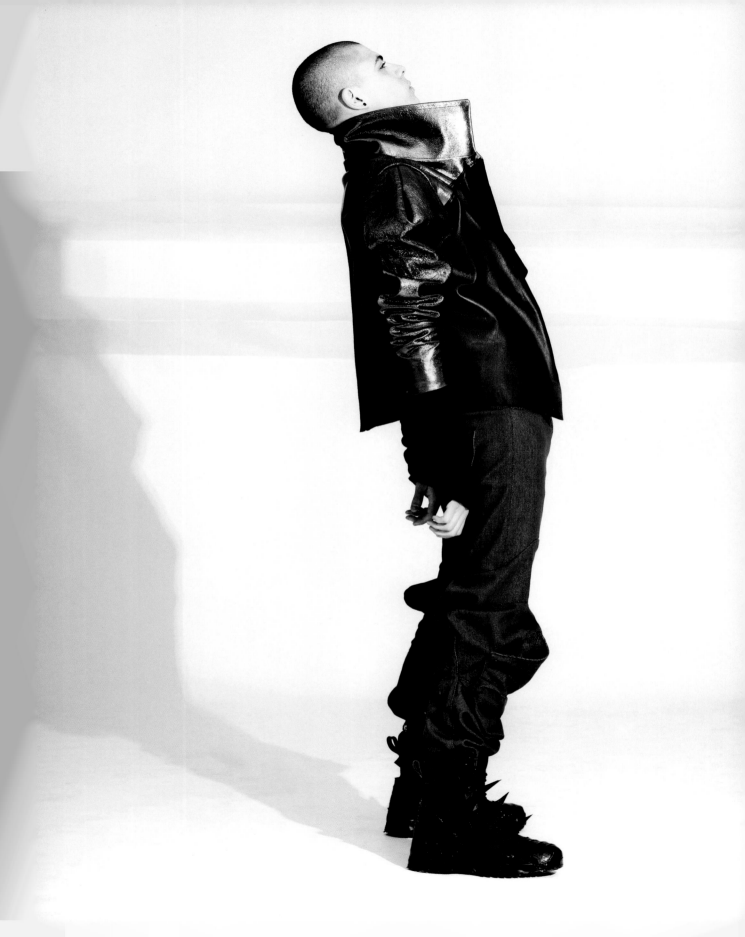

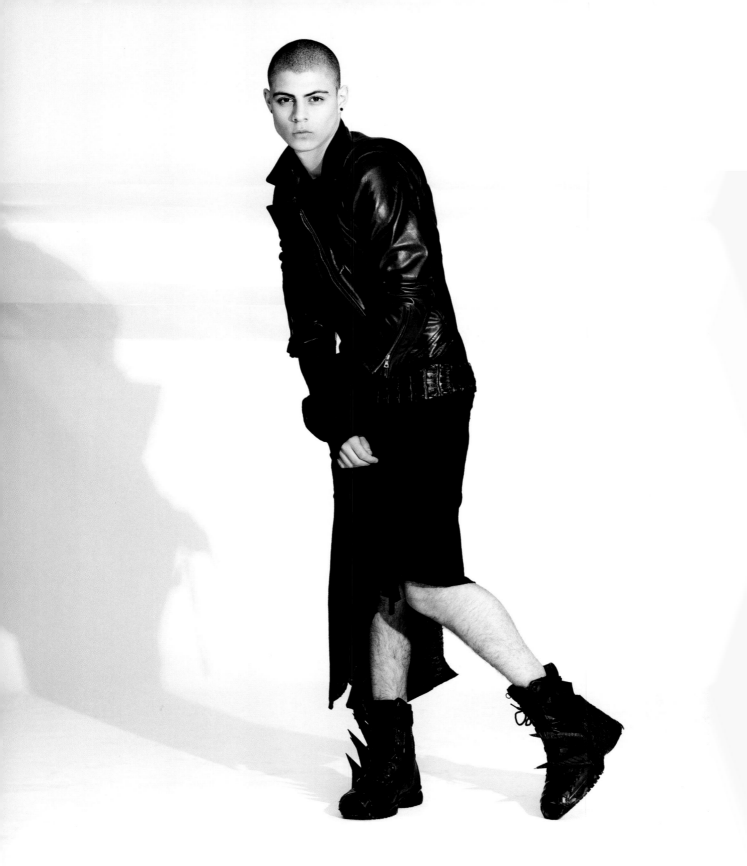

fashion designer

Barbara Í Gongini

http://www.barbaraigongini.dk

I was born in the Faroe Islands and I have been living in Denmark since 1990. I graduated from the Danmarks Designskole (Danish Design School) in 1996. In 2002 I joined an innovative design collective called *Kônrøg* and in 2005, I launched my own label in Copenhagen, Barbara i Gongini. Today we have concessions in 40 different countries.

I aim to break boundaries within Nordic design, giving it a stronger edge. I work with concepts where the process and experimentation dictates the expression of form. I work with the roughness and depth of the dark poetry emanating from the north – the Faroe Islands, my first home – playing with aspects of minimalism and the democracy between the sexes which is reflected in the androgynous style of my work. My newest collection incorporates everything from minimalism to multi functionalism; the palette is mainly black and white with a few shades of grey, and there is a wide variety of textures and fabrics including leather, plastic, cotton and fur.

We have three lines: the main collection, B-Black, an avantgarde basics range, and accessories which will soon include shoes. Every season I collaborate with different artists from different environments. This season I will make a film with Marianna Mørkøre, a fellow Faroe islander, and will also work with Ben Porter Lewis the poetry slammer from NYC and

Berlin-based street artist, El Bocho.

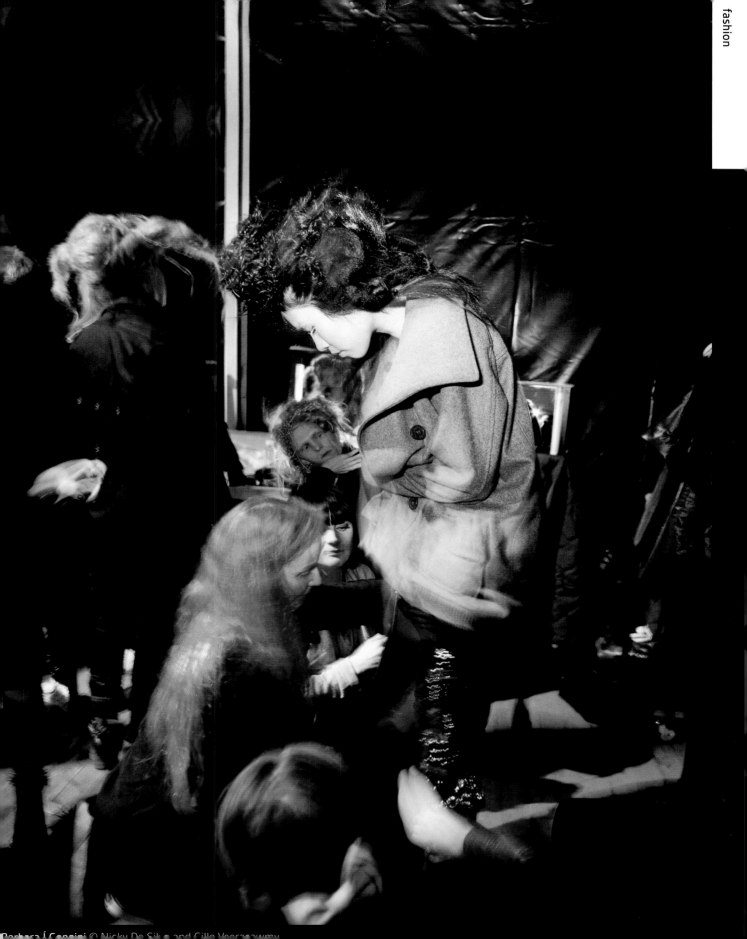

Barbara Í Gongini © Nicky De Silva and Gillo Veeragawmy

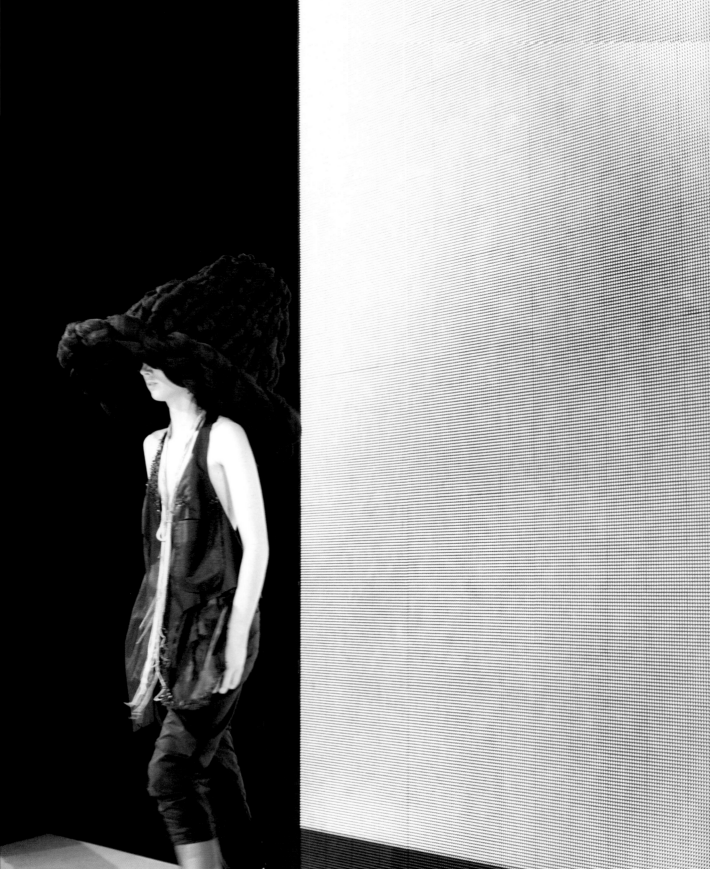

Barbara Í Gongini

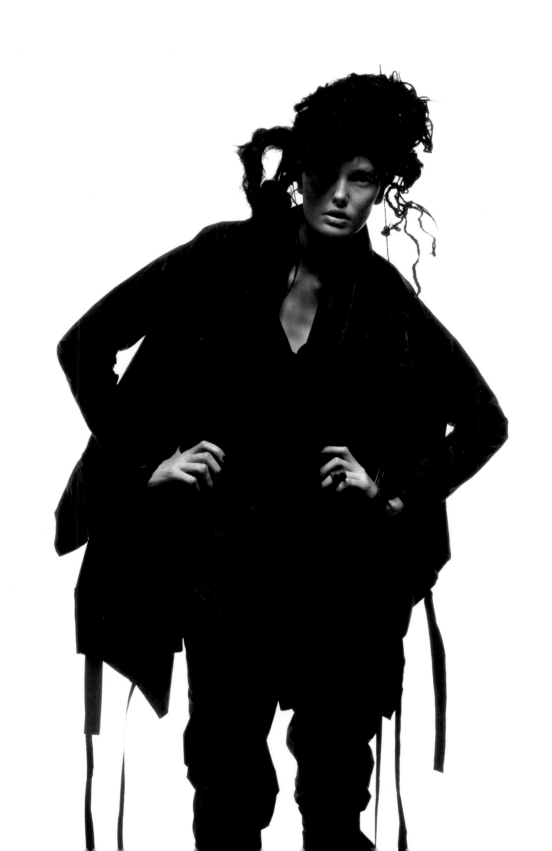

fashion designer

Claude Maus

http://www.claudemaus.com

The Claude Maus name was born as a pseudonym for Melbourne-based fine artist and graphic designer, Rob Maniscalco. In 2000, the Claude Maus name evolved into a fashion label and quickly established itself as one of Australia's most dynamic and challenging brands. 2001 saw Claude Maus win the Mercedes Australian Fashion Week Start-Up programme. This accolade was followed with prizes for Designer of the Year in both the men's and women's categories at the 2003 L'Oréal Melbourne Fashion Festival.

Each Claude Maus collection is created thematically, combining traditional tailoring and high quality fabrics with unique graphics, referencing the dark side of popular culture. An aversion to mainstream trends paired with an intelligent approach to fashion means a distinct, truly original style. Claude Maus' references include Nordic culture and pagan folklore combined with modern music culture. The label's trademark mix of washed leather, fine silk satins and soft jerseys is used to form garments that are an eclectic mix of minimalism, formalism and American-folk styles, all of which translate to modern times.

The Claude Maus range mixes drapery and layering with raw edges, folds, twisting and curved lines, creating a bucolic yet refined look. Charcoals, muds, dirty whites and shades of black are all used to add extra dimension to layering and depth. Leather is central to the Claude Maus range with new and experimental leather techniques being applied to traditional tailoring methods to produce sublime soft and textured leather pieces.

Designer Rob Maniscalco's confidence in his ability to combine traditional methods of tailoring with a modern approach to drapery and constant desire to push boundaries is borne out in the label's growth.

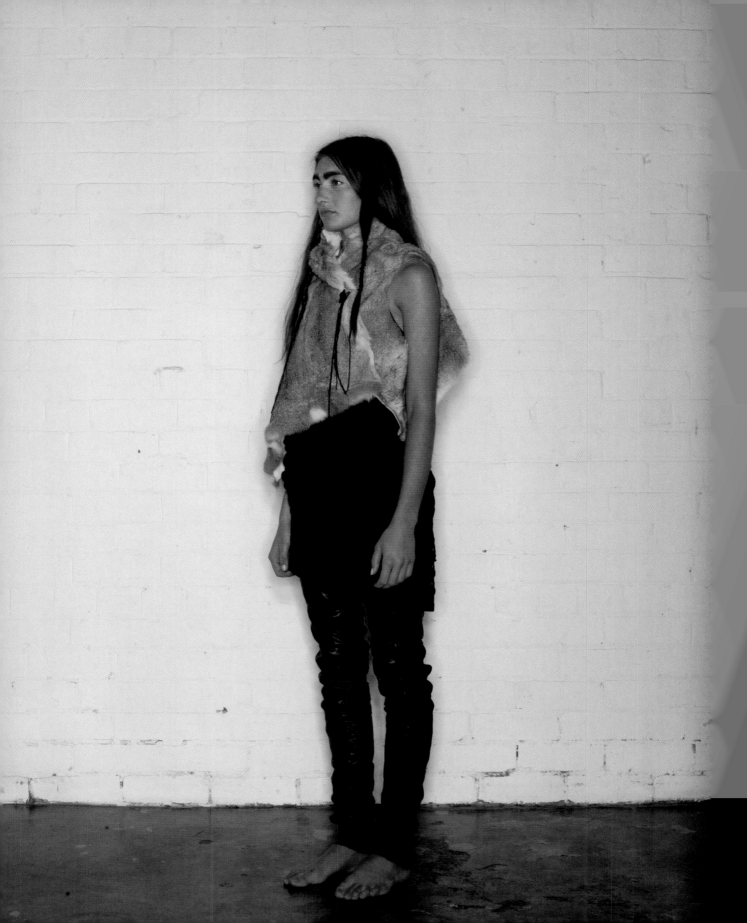

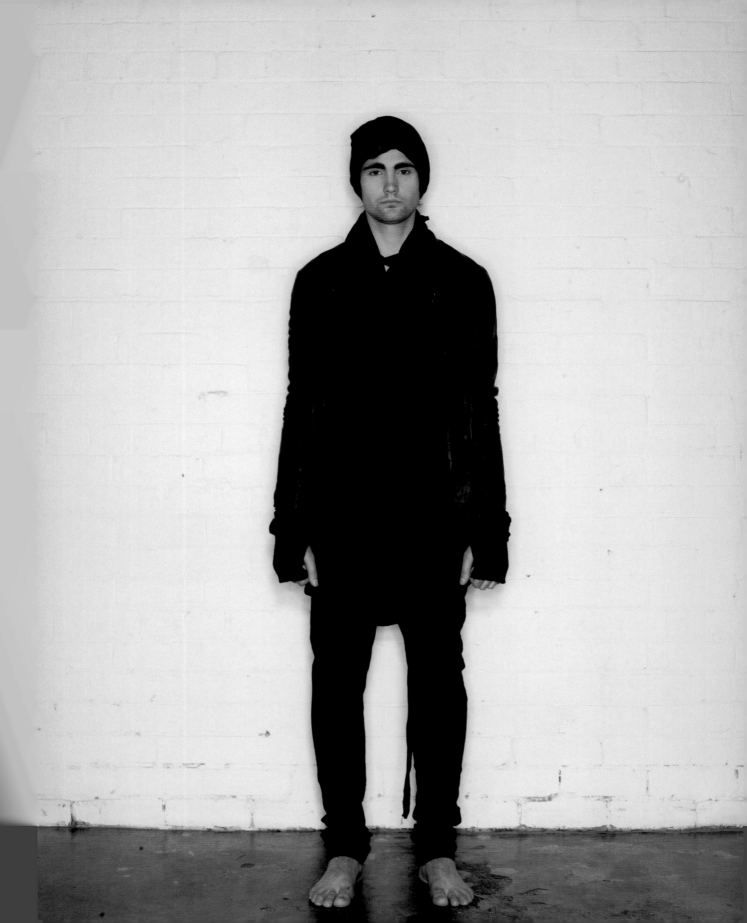

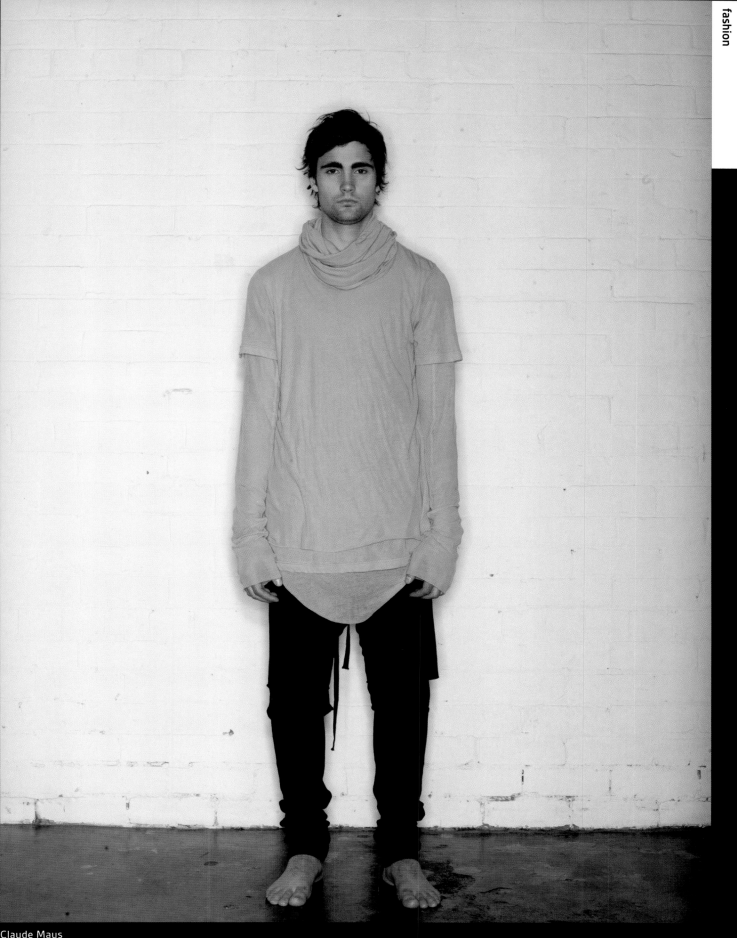

Claude Maus

fashion designer

Damir Doma

http://www.damirdoma.com

Damir Doma is a high-fashion, luxury brand founded in 2006 by designer Damir Doma and the Paper Rain Group. Over a short period of time, Damir Doma has become an established name among the big Parisian luxury brands and the collections are available in leading fashion boutiques worldwide.

Damir Doma's ethereal designs are inspired by the fragile, ephemeral qualities of the human body, multiple expressions of identity and evanescent impressions from ever-evolving surroundings. They explore interpretations of contemporary masculinity and femininity and express themselves in avant-garde silhouettes. Fusing mind, body, and spirit with fabrics, colours and shapes, the collections introduce the designer's personal aesthetic to the world of fashion. Draped silhouettes, flowing volume, double layers and soft tailoring, in exquisite and carefully selected fabrics, characterise Damir Doma's work. The search for soulfulness and sensitivity in the collections has evolved into a thoughtful and complex sensibility in all garments and accessories.

Beginning with his first collection in June 2007, Damir Doma has offered avant-garde minds all over the world a truly inspiring alternative to contemporary clothing lines. The confrontation of an endlessly evolving heterogeneous environment combined with the designer's uncompromising ideas on fashion and the arts, have led to a strong and recognisable identity, visible throughout the collections.

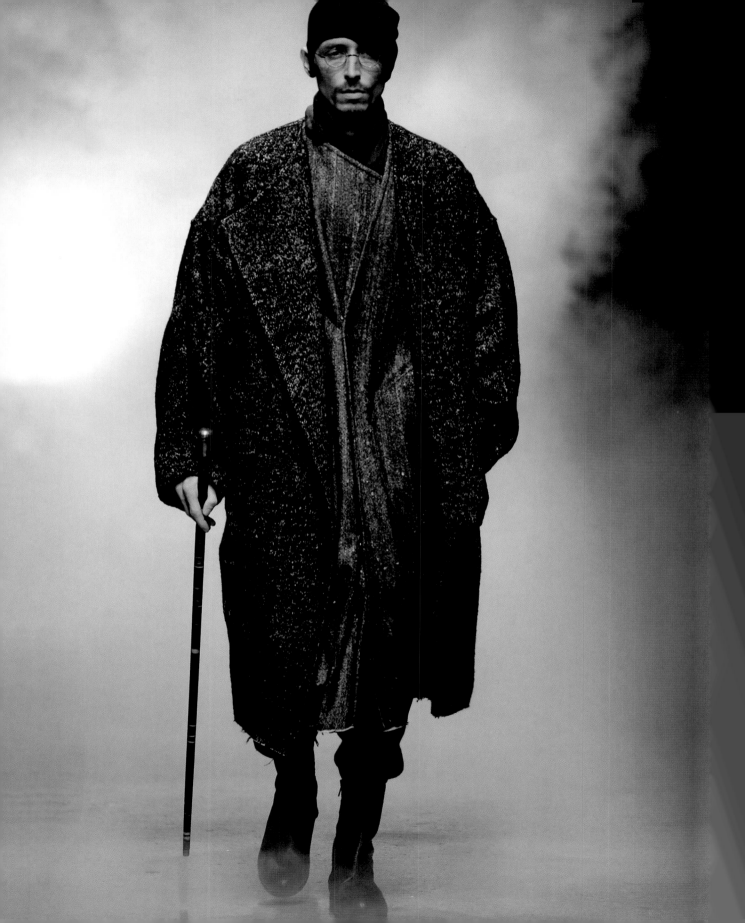

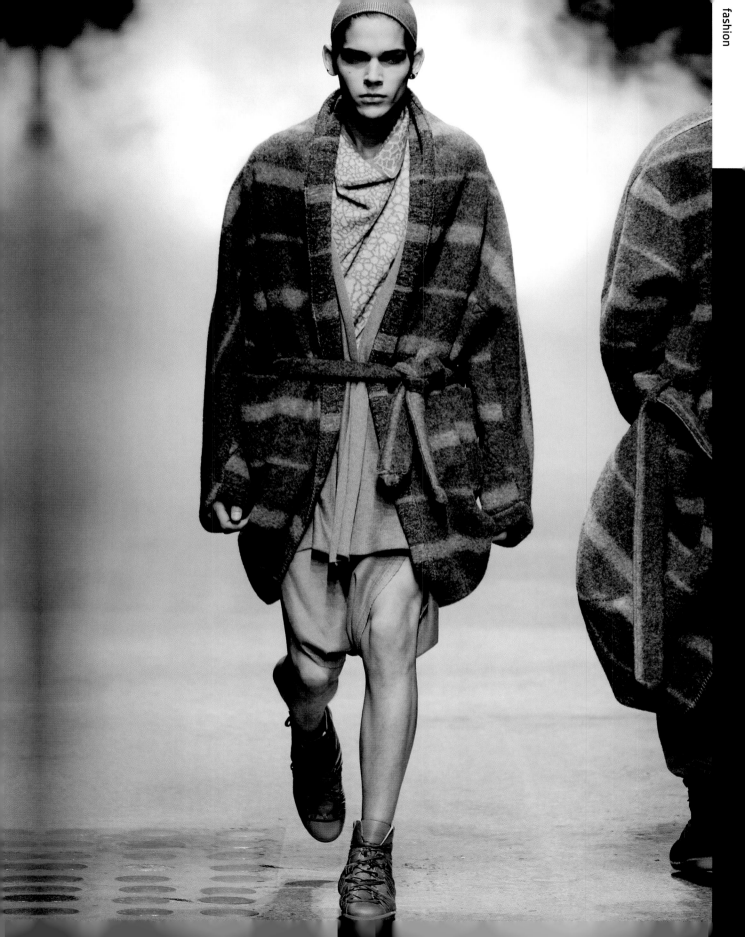

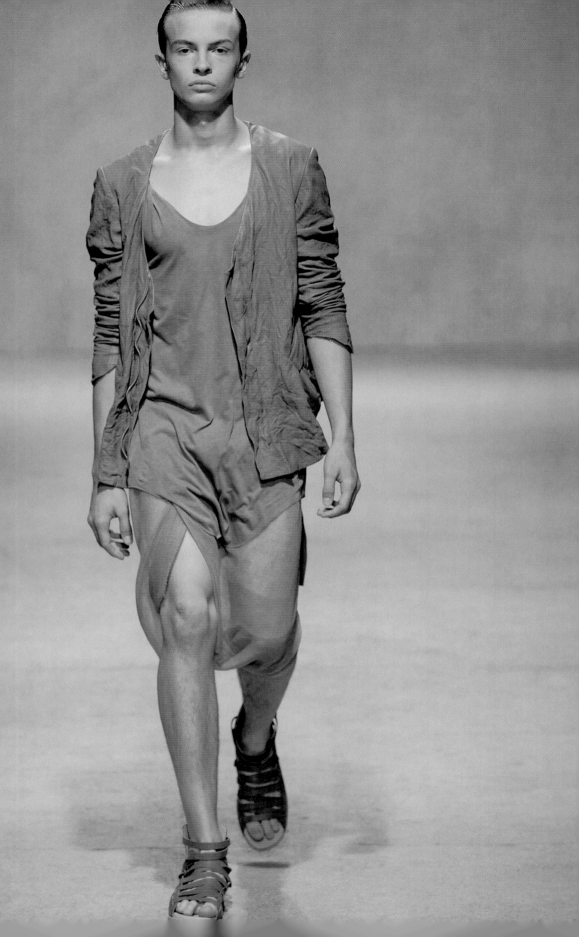

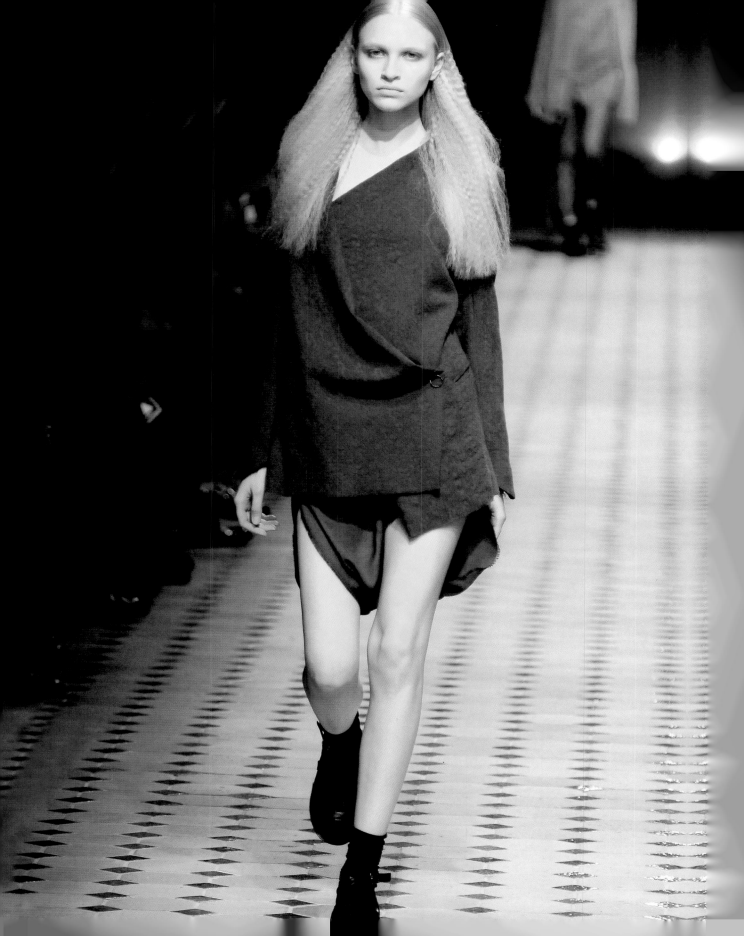

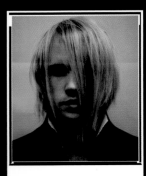

fashion designer

Obscur

http://www.obscur.se

Richard Söderberg, the designer behind Obscur, has always been fascinated by society and his surroundings. Having always wanted to reshape classic silhouettes, Swedish-born Richard takes inspiration for his collections from the dark and misty landscapes of his home country. He is also drawn to dark Scandinavian music and tries to translate its rhythms to his garments. Obscur, as an artistic outlet for Söderberg, aims to become one with the wearer in the eyes of the onlooker.

So what made him decide to become a designer? Richard has thought about this throughout his career but he is still uncertain why he is who he is today. 'At first, I had no intention of becoming a designer but I think that some human beings are born with an urge to be creative. I think that working as a designer is crucial for quenching my creative thirst.' At the start, Söderberg had no intention of even selling the clothes he made. The pieces were just the overwhelming result of his urge to create. Nonetheless, Richard is very aware of what surrounds him, so the clothes he creates for Obscur are ones that he personally wants to wear and he believes that identity is something that grows and evolves.

The Obscur designs can be seen as a morbid encounter between energy, abstraction and our souls. The materials meld with the body, becoming one. The raw, outer shells of the pieces consist of cotton, wool, cashmere and thick, raw leather, which keep the living from momentarily disintegrating. The naturally coloured fibres preserve your energy by keeping the world one step away. The leathers have dyes and treatments removed in order to get closer to a state of solemn austerity and sterile manifestation. Many of the pieces are constructed with frayed collars and sleeves, which can be removed to create a unique silhouette and provide shelter to your skin. The signature raw edges are often incorporated in the designs, to allow for smoother layering when combining different garments.

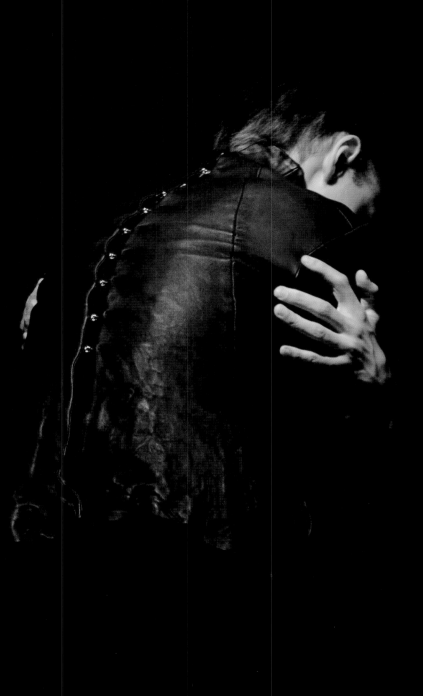

Obscur

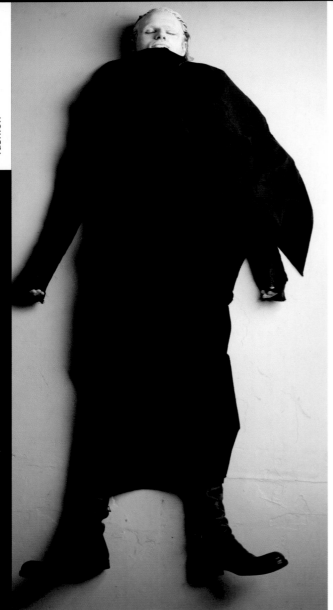
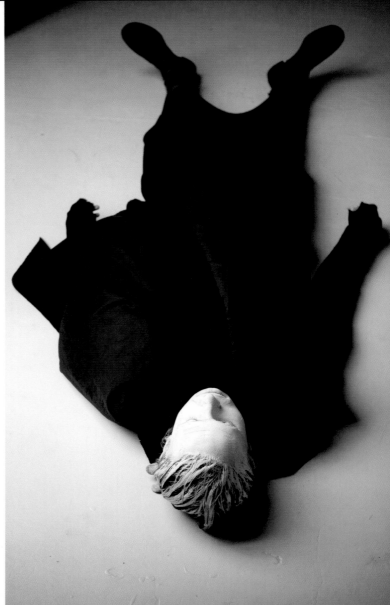
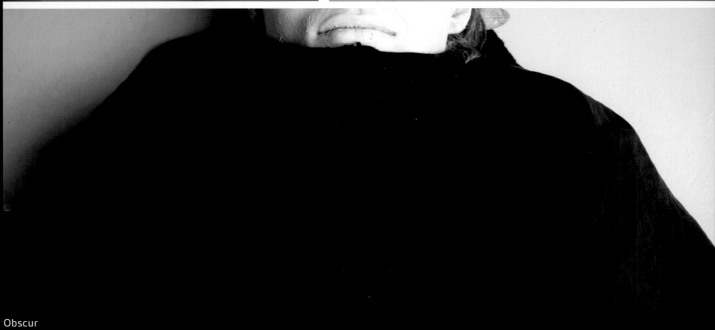

Obscur

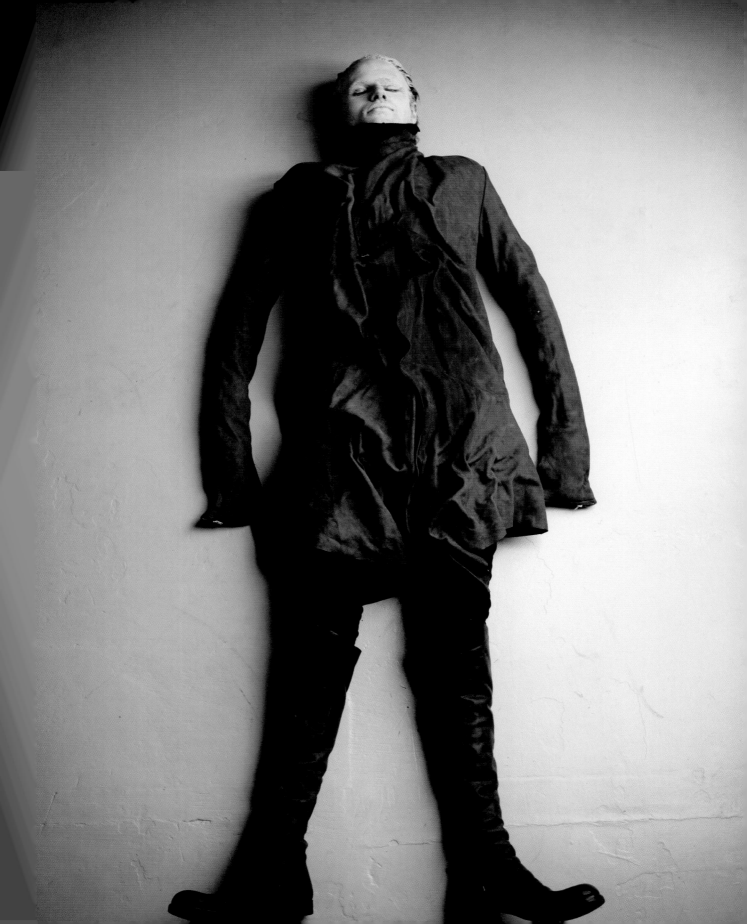

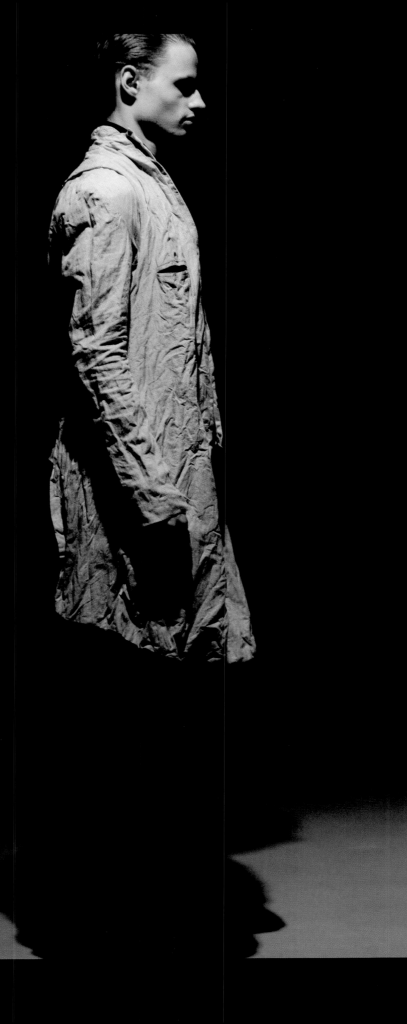

Obscur

fashion designer

Pam Hogg

http://www.pamhogg.com

Pam Hogg studied Fine Art and Printed Textiles at the Glasgow School of Art where she won the Newbury Medal of Distinction, the Frank Warner Memorial Medal, the Leverhulme Scholarship and the Royal Society of Arts Bursary, which allowed her to pursue further studies at the Royal College of Art in London, where she gained her Masters of Art degree.

In the eighties she infiltrated the elitist ranks of the conventional fashion world with her self-taught wild brand of outrageous creation and established herself as a highly respected designer. In 1989 Hogg opened her first standalone boutique on Newburgh Street, just off Carnaby Street. During the Nineties, she formed a number of bands including Doll and Hoggdoll, wrote scripts and songs, directed a fashion film, showed in a travelling art exhibition. Her one man show at the Kelvingrove Art Galleries in 1990 was the first fashion design exhibition to be held in the grand Glasgow Museum and was received extremely well. She produced and directed her own London Fashion Week catwalk shows for six seasons until 1992 when she switched focus from fashion to music. In May 2009 she opened a pop-up boutique in Newburgh Street stocking her trademark colourful clothing, archive pieces and a range of Pam Hogg crockery.

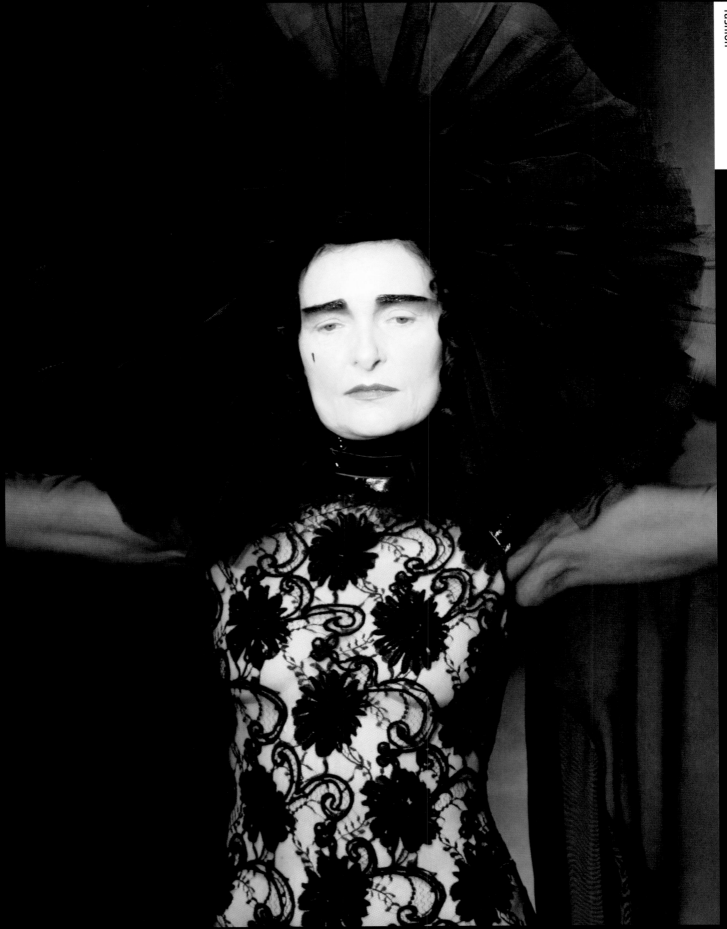

Pam Hogg © Jorge Margolles

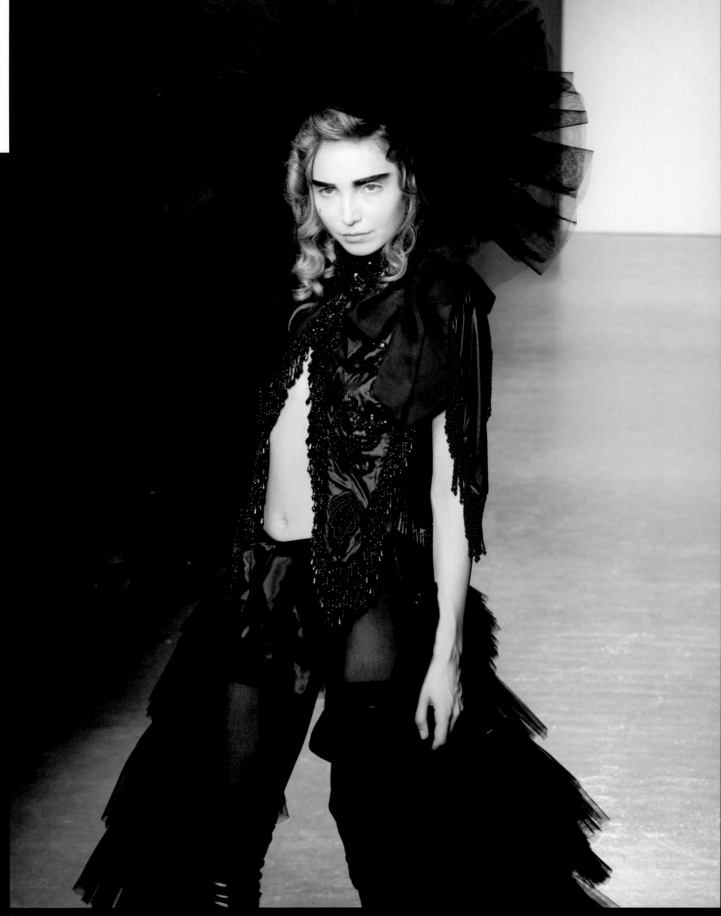

Pam Hogg © Jorge Margolles

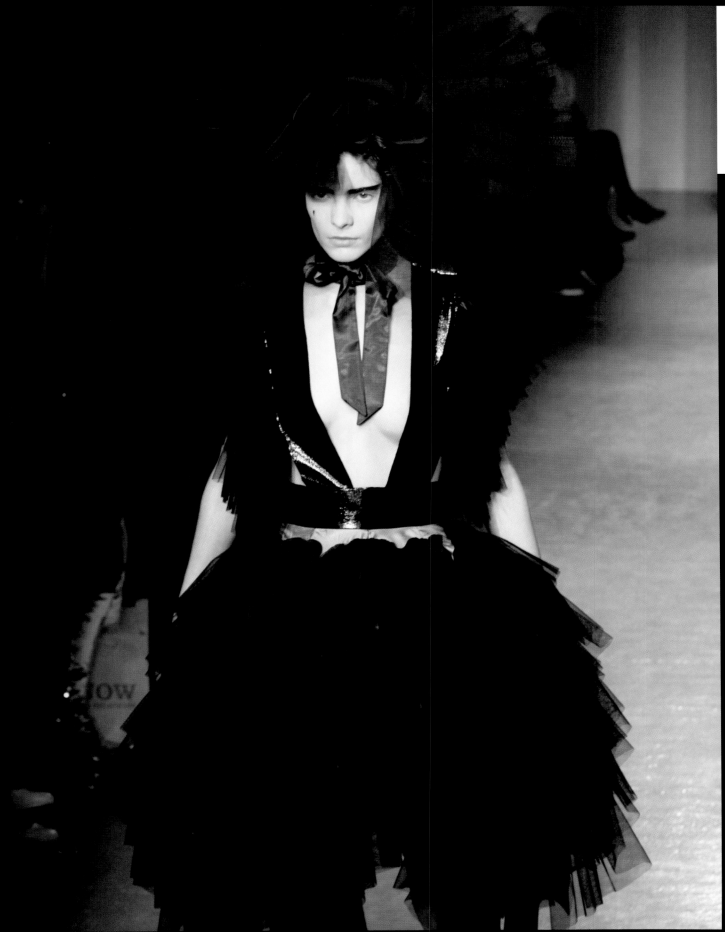

Pam Hogg © Jorge Margolles

Pam Hogg © Jorge Margolles

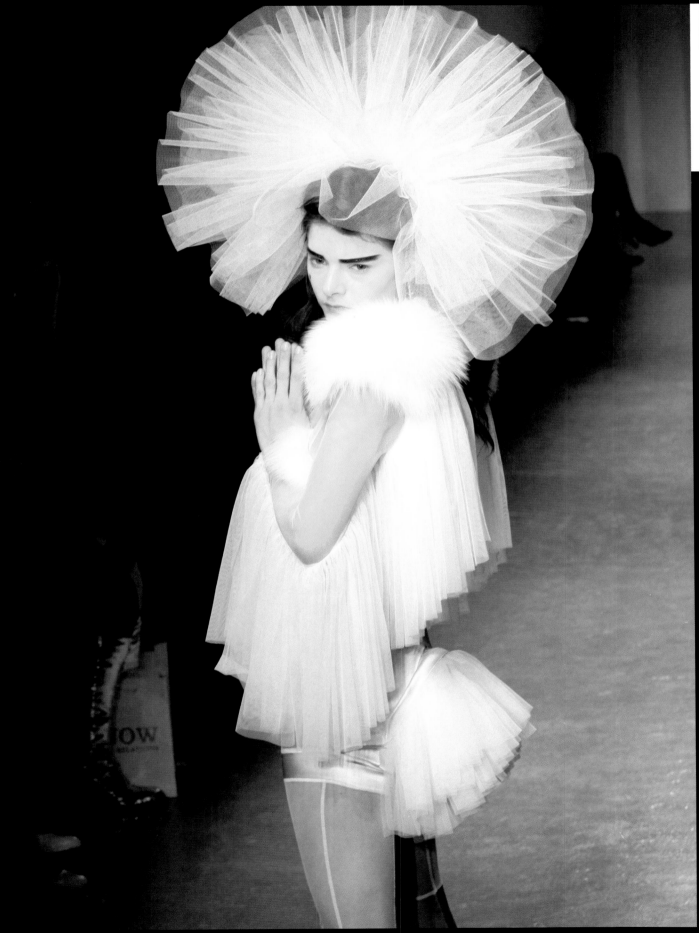

Pam Hogg © Jorge Margolles

fashion designer

Wuyong (Useless)

http://www.wuyonguseless.com

My understanding of clothing as a designer took me a decade to reach. I realised that the world has no shortage of fashion designers who are capable of making trendy, elegant, sexy and sophisticated garments, but that it is badly in need of designers who make clothes that are simply clothes. My definition sets fashion and clothing apart. It is a fact that there are plenty of beautiful garments in shopping malls and high-end boutiques, whose very unpredictability makes our life colourful and compel a multitude of desires. You are almost convinced: you can buy whatever you dare to think of.

As my experience grew, my attraction to art became stronger. The world of art revealed new spiritual prospects: food for the heart and a sense of happiness similar to catching sight of a friend from a past life. My journeys into the remote countryside, far away from urban life, enable me to think deeper thoughts and to explore the values of life. I am no longer satisfied by the practical and ornamental functions of clothing, nor by breakthroughs in form and even less by a drive for reputation or profit. I yearn for clothing to stand, like paint to the painter or stone to the sculptor, as a simple and particular language of individual creation which draws the audience from an appreciation of the surface to deeper thoughts and conversations with the world of the soul. I want to explore the mental life and spiritual world of human beings. I believe the greatest works of art can touch the deepest and strongest parts of human feeling and that these works can be the memories of history, preserving the most valuable feelings that have ever existed and inspiring a greater awareness of ourselves.

I believe clothing can be a specific creative language, and has infinite possibilities for communicating ideas and transmitting thoughts, for inspiring you and shaping your behaviour. The spiritual qualities which I pursue stand in complete opposition to modern fashion trends. What I find profoundly engaging is the primitive epoch in human history, when people held nature in the deepest reverence and made objects of the utmost simplicity.

Above all, my understanding of clothing and the designer's role comes from my exploration of the values of the world and human life, which has become part of my creative drive. I truly believe in the pursuit of the meaning of life and spiritual values, and this has kept me going. To me, creativity is a long process of self-cultivation, not looking towards a distant goal, but small steps. I am devoted to creating the most essential, the simplest, while also pursuing a rich spiritual life.

– Ma Ka of Wuyong, a Chinese brand launched in 2006.

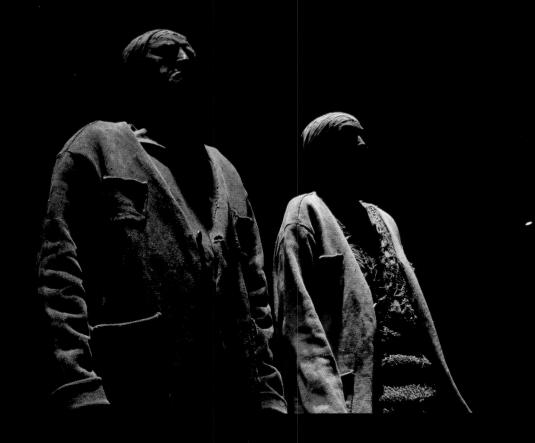

Wuyong Studio

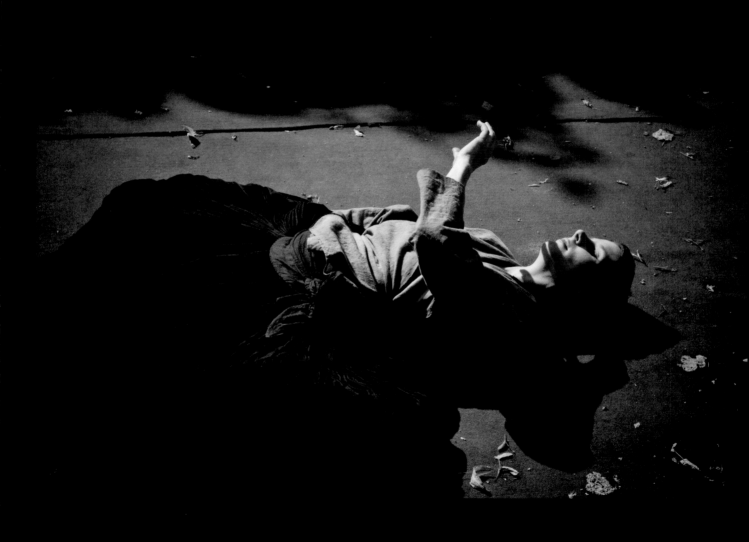

Wuyong Studio

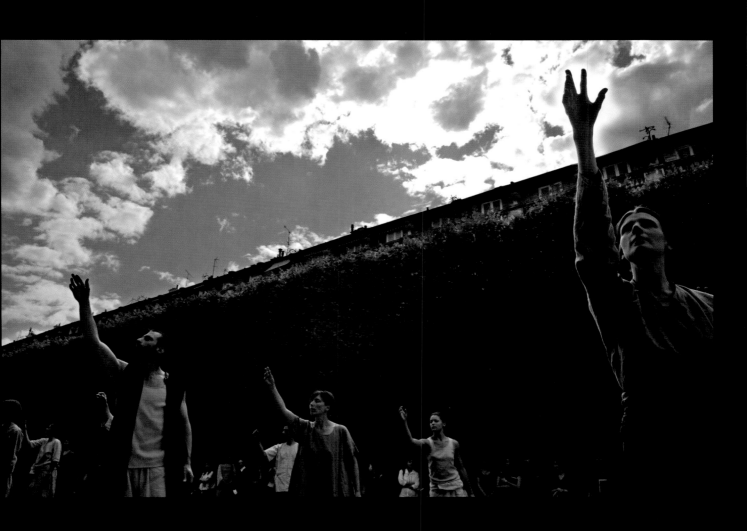

Wuyong Studio

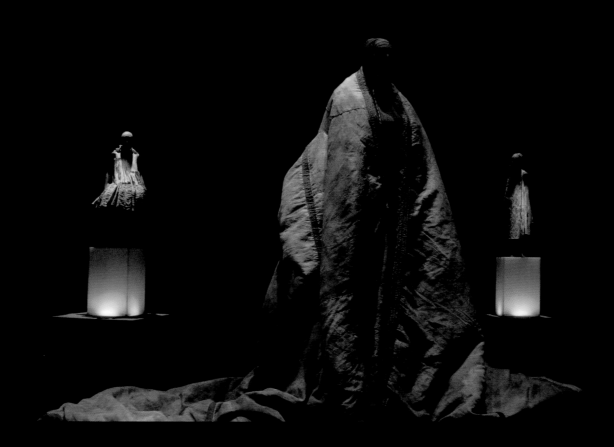

Wuyong Studio

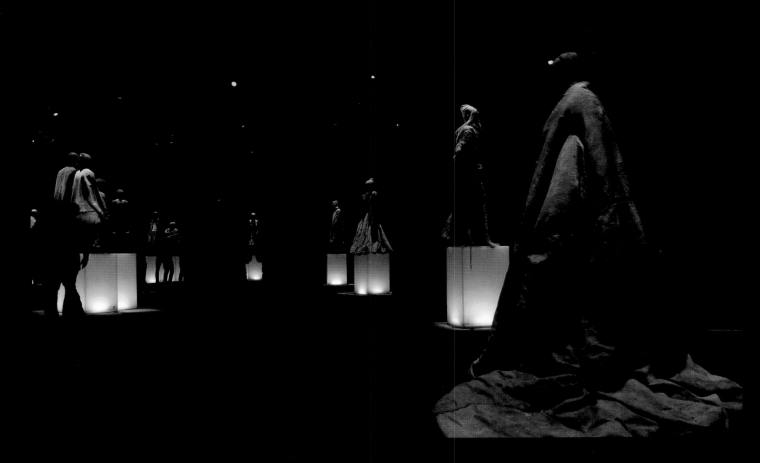

Wuyong Studio

fashion designer

Zazo & Brull

http://www.zazobrull.com

Zazo & Brull is a young label founded by Xavi Zazo and Clara Brull. They met at the Llotja art school in Barcelona where Zazo studied design. Later he took a course in conducting patterns at the American Mitchell School. His collections embody the duo's passion for stories of uncertain outcome, and use them to heal their neuroses and obsessions. They understand fashion as an artistic expression. Their collections are truly communicative: true stories full of unbelievable beauty that are above the dictates of ephemeral trends. The quintessence of romance in dark shades is their trademark.

They began working together in 2000 and created the label in 2003. Its collections have been presented in the showroom and the gateway of 080 Barcelona Fashion, at the Bread & Butter fair, at the Showroom Barcelona in Paris and at the Pasarela Gaudi in Fashion Hall of Madrid. They have also been invited to participate in the Festival Noovo, Fashionable and Contemporary Photography Exhibition at the Fashion Bolivia event in Santa Cruz and the Pasarela Gaudi Novias.

Fragile, the most recent collection, has been featured at the Santa Monica Art Centre, Barcelona, giving them the chance to combine art and fashion via an installation. Recently they were among the 10 finalists in the Mango Fashion Awards and were the only Spanish representatives. Their designs have been seen in prestigious magazines, including British, Italian and French *Vogue* as part of a Mario Testino editorial, *Collezioni*, Italian *Glamour*, *L'Officiel*, *Collections*, *Surface*, *Stilomag*, *On Design*, *Sport & Street*, *iD*, *Fashion Windows*, *Neo2*, *Stylesight*, *Fashion Reading*, *BMM*, *Avenue*, *Mini Guide Russia*, *Jewel Magazine*, *Noovo Editions* and a number of Spanish newspapers including *La Vanguardia*, *El Mundo* and *El Pais*.

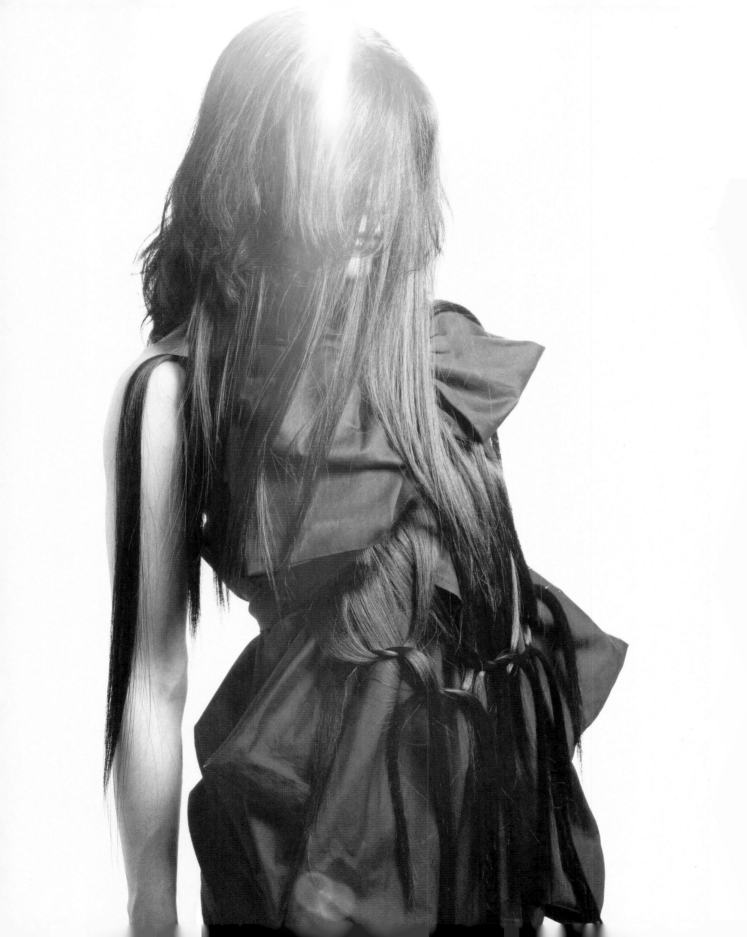

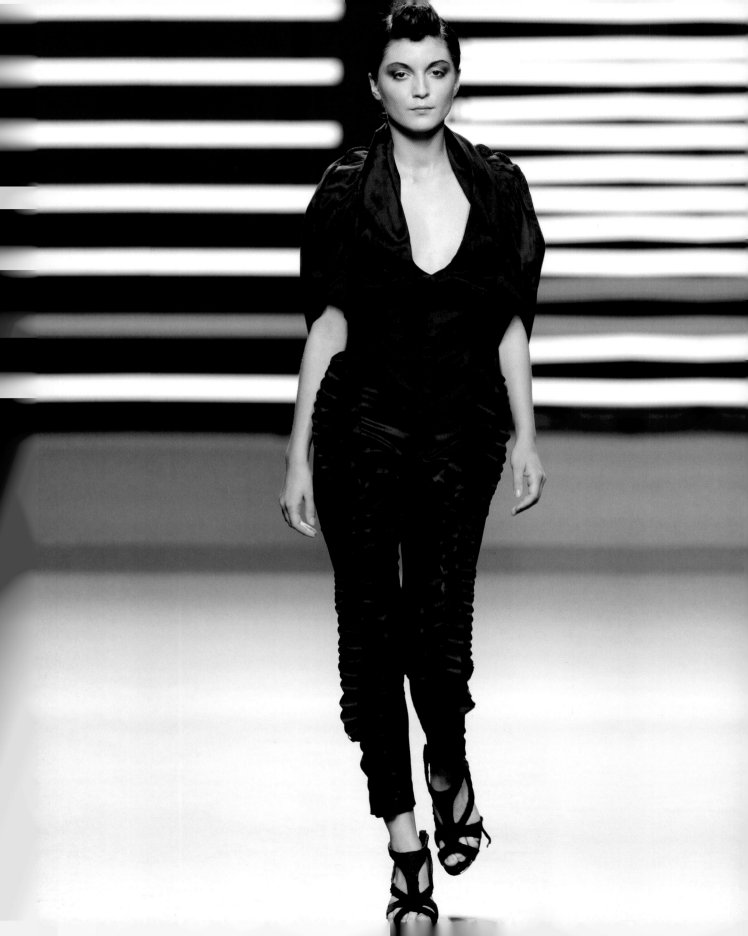

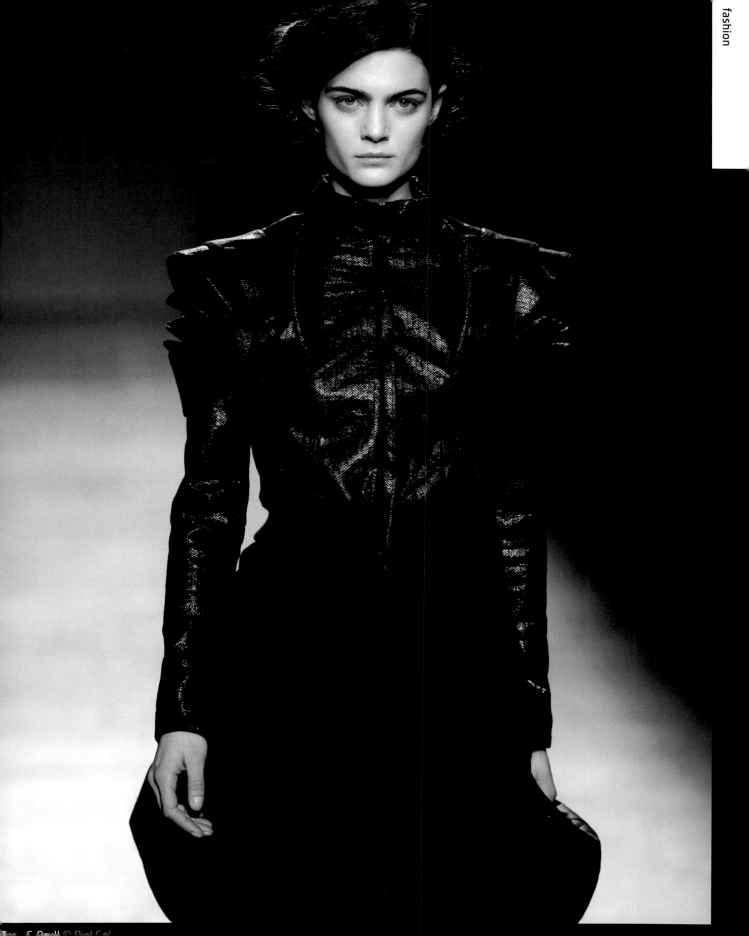

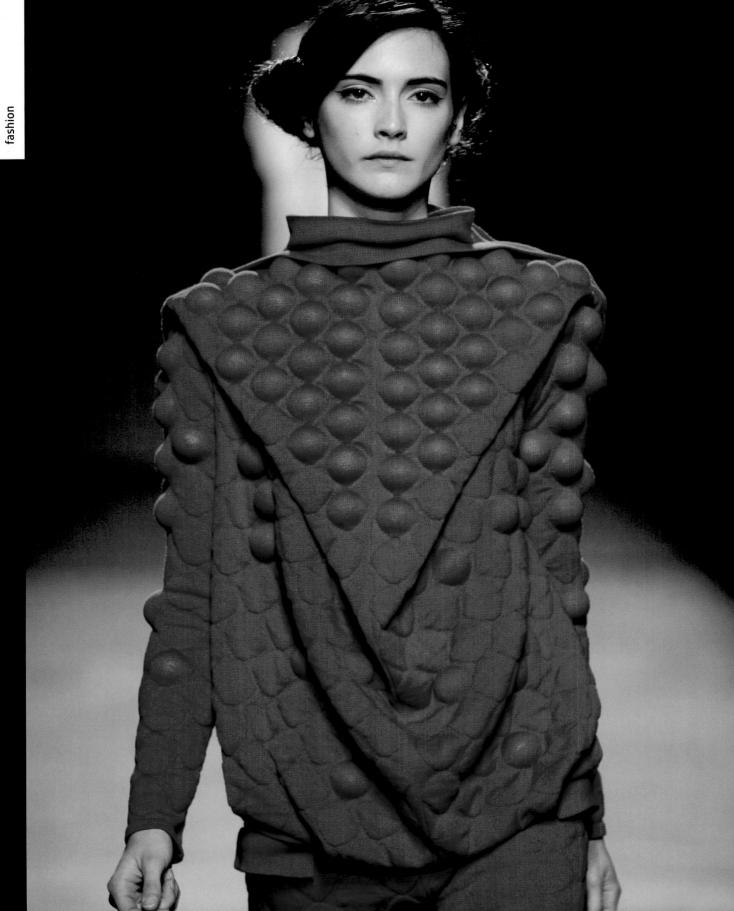

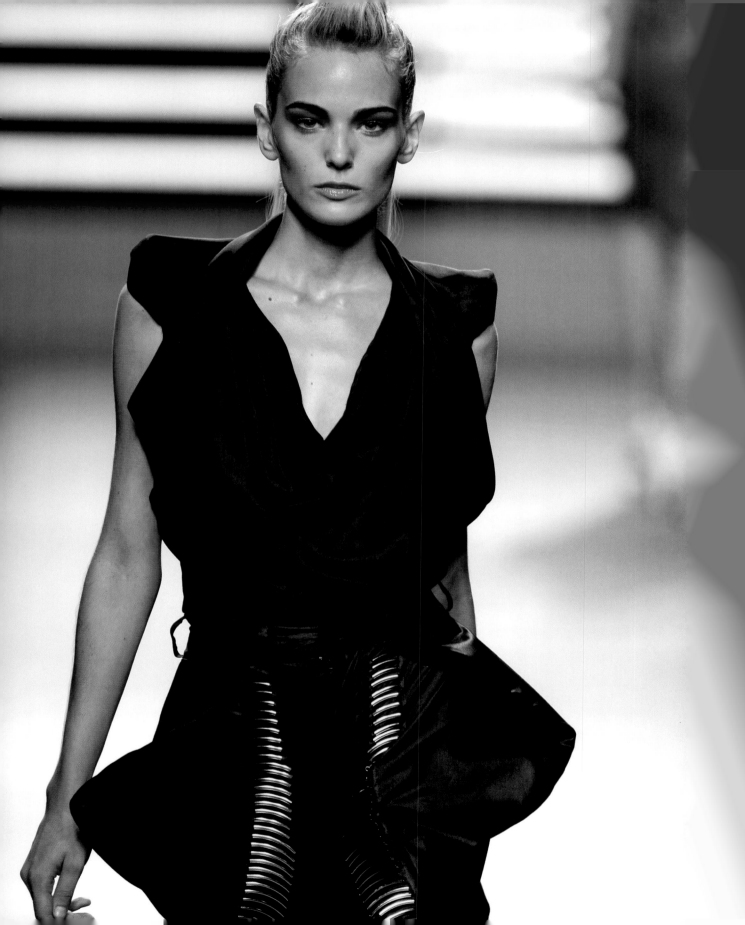

glasses designer

A-morir

http://www.a-morir.com

Founded in 2008, A-Morir by Kerin Rose has made heads turn and jaws drop. Each meticulously crafted creation, adorned with Swarovski crystals, spikes, chains, lace, studs or pearls, reflects Kerin's love of the theatrical, the luxurious, and most importantly, the glam. From working with Patricia Field to her current sales on Karmaloop and in boutiques around the world, each item is hand made with premium materials and always with the discerning tastemaker in mind.

A-Morir, the eyewear and accessories collection, has become a favourite of some of fashion's biggest trendsetters. The designs have been worn and loved by the likes of Rihanna, Lady GaGa, Mariah Carey, Katy Perry, Snoop Dogg, Fergie, Nicki Minaj, Estelle, Cassie, Jazmine Sullivan and Kid Sister; and have been also featured in editorials by Italian *Vogue*, *Rolling Stone*, *Vibe*, and international versions of *Marie Claire* and *Nylon*.

Though Mariah Carey was first to discover A-Morir, the spotlight was really turned on Kerin Rose when Rihanna chose and wore the 'Barracuda' glasses in the video for *Run This Town* with Jay-Z and Kanye West, in her seminal Italian *Vogue* cover shoot and for the inaugural Fashion Night Out in New York. Kerin has since designed a special collection of eyewear and accessories for designer Christian Siriano's Fall/Winter

2010 collection shown at New York Fashion Week and was voted the 'best in class' honoree by Nike at their annual design conference.

86

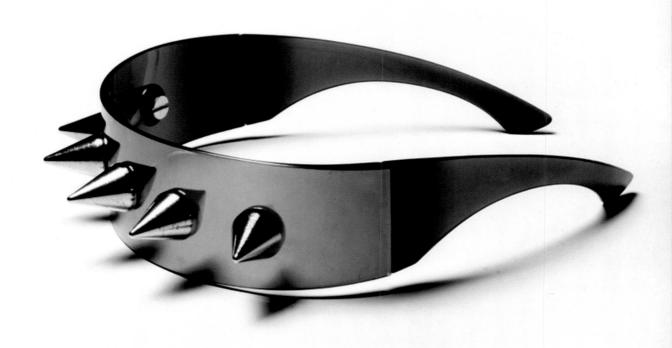

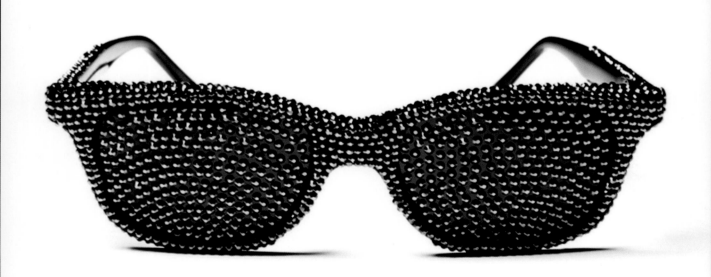

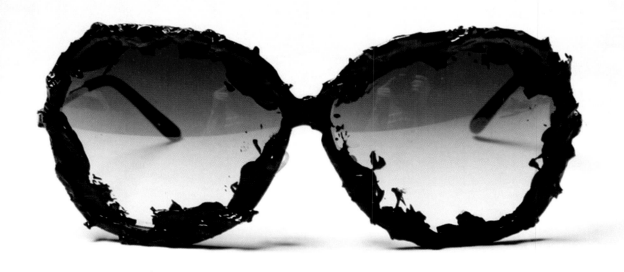

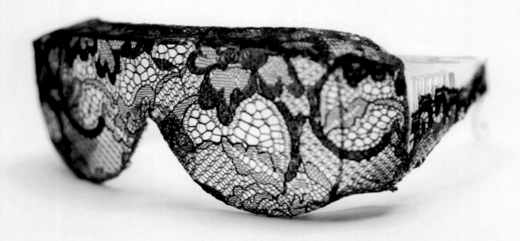

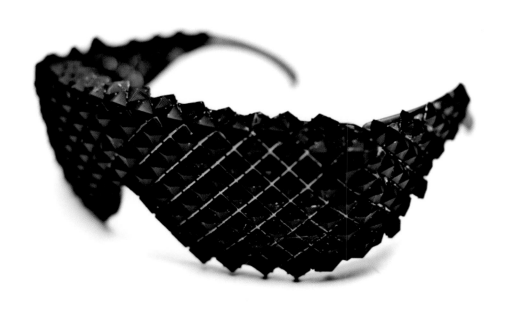

glasses designer

Graz

http://www.grazmulcahy.com

From sunlight to strobe light, Graz is a brand that is influencing the direction of global eyewear trends and resonates to new points of cultural significance across design and music.

Graz was founded by Graz Mulcahy, a designer who cut his teeth working at AM Eyewear; a label synonymous with the street-meets-surf-meets-boutique Australian fashion culture. After a stint at AM, he left to take up the reins as head designer and founder of the Tsubi (now Ksubi) range of sunglasses. Having built up the brand, Mulcahy left to create to his first truly personal range: Graz.

The Graz optical and sunglasses range creates the impression of high modernity coupled with an undertone of the elegant. The finishes are polished and proportioned, but utterly innovative, without ever becoming unnecessary, either in shape or construction. Far removed from ranges that merely rework past classics, the Graz range is truly unique. From a consumer perspective this translates to pieces that will be worn and loved for years. There is a greater chance that you'll destroy or lose a piece of the Graz range before you archive it.

The success of the designs is mirrored by the stockists: Barneys in New York, Maxfields in LA, Colette in Paris and Poul Stig in Copenhagen, and also by the list of Graz collaborators which include Ellery and Chronicles of Never. However, it is Mulcahy's continuing interest in brand extension and emerging cultural groups that put Graz in a class apart. Graz is expanding into new categories. Some of these steps are small and logical such as a luggage and accessories line. Some of these steps are running parallel to what the Graz line represents: the link to music is emphasised via a vinyl and digital edits series that will be released under the brand this year. And some of these steps are directly connected to those who like the music and wear the pieces, as these people form part of The Circle; a network of people whose taste includes both.

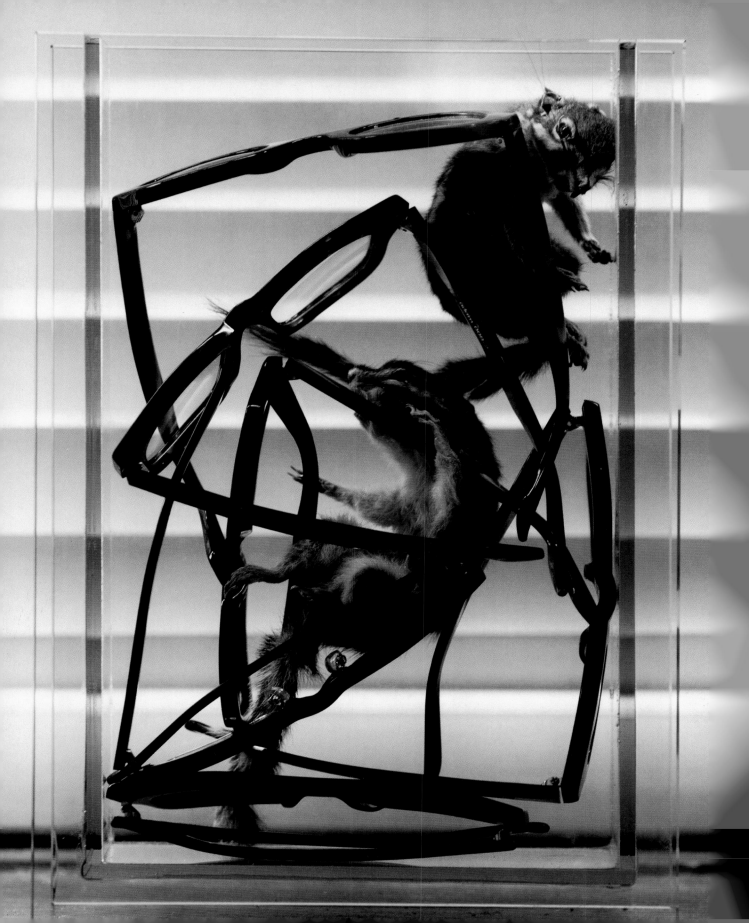

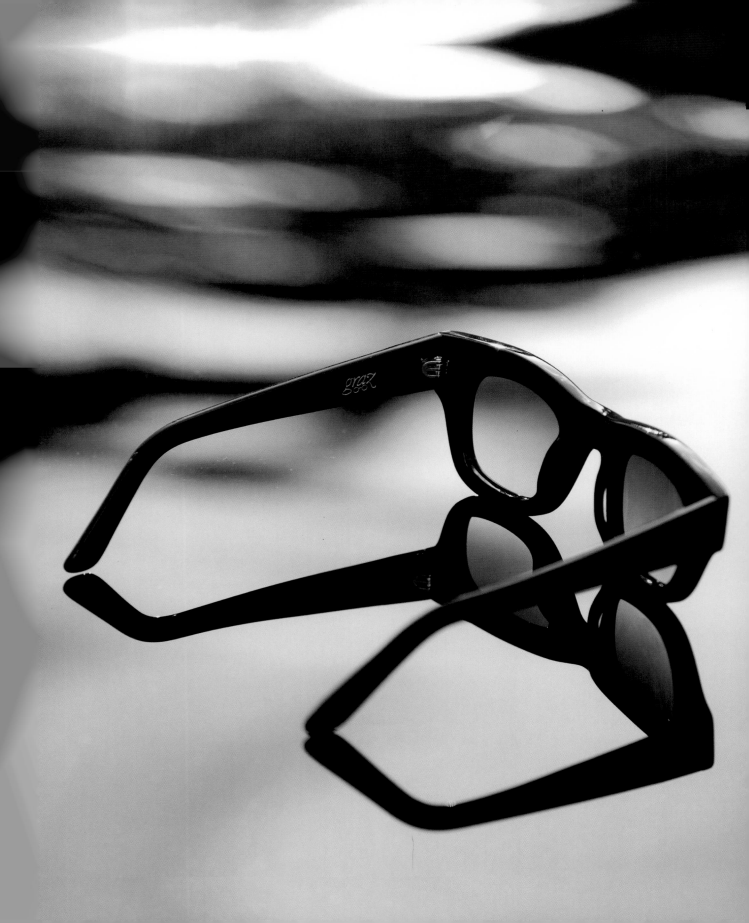

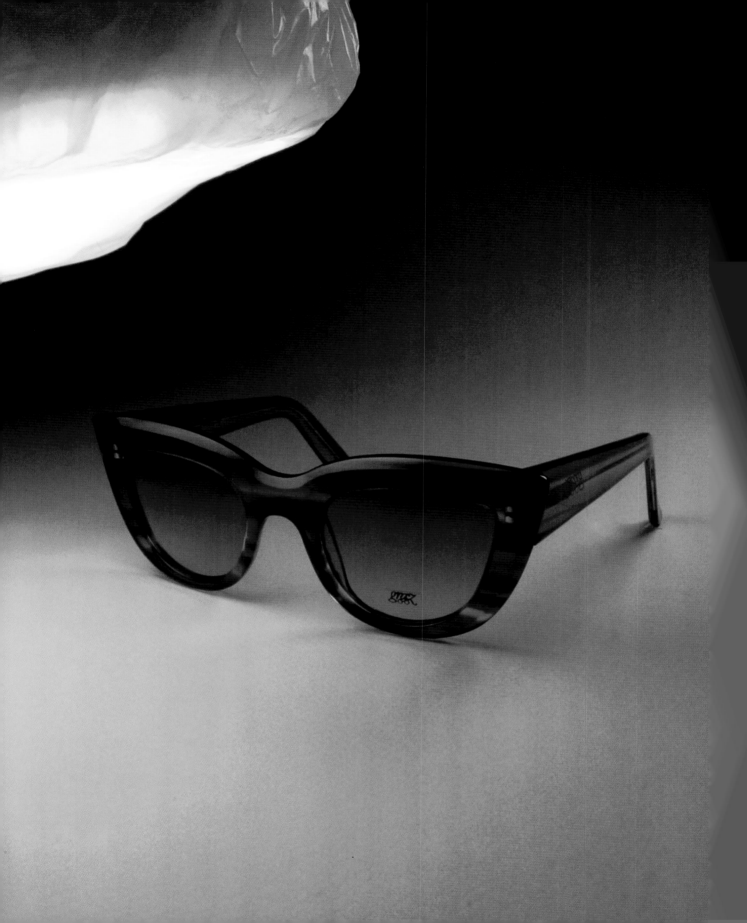

glasses designer

Herrlicht

http://www.herrlicht.de

Craftsmanship and individuality are two of the many qualities espoused by Herrlicht frames, the original wooden glasses. Made by hand in the workshop of their designer, Andreas Licht, Herrlicht frames are 100 percent wood, either walnut, maple or pear. The material is very light, and has warmth, flexibility and uniqueness. These are not mass products. Each frame has its own story to tell, much like the rings of a tree. No wonder Herrlicht has become synonymous with wooden glasses.

With years of experience in wood work, Andreas Licht produces refined and elaborate frames that are easy to handle, thanks to the special hinge system that includes a tiny brace which looks like a four-pronged star and makes it easy to change the lenses. Another important element of the Herrlicht collection is the beautiful case, Pyxis I, also made of wood. It matches the frames not only in material but also in elegance. The cylindrical form opens up like a pod in a sophisticated way. With people returning to values such as sustainability and timelessness, Herrlicht frames are becoming increasingly sought after.

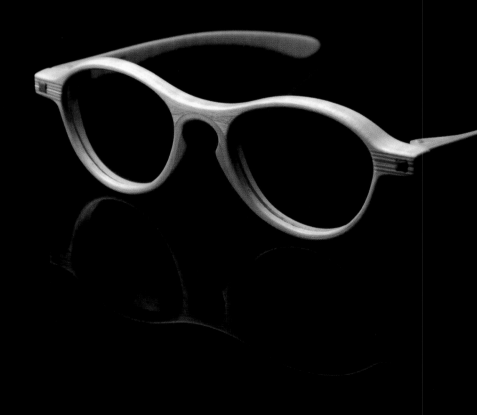

Herrlicht

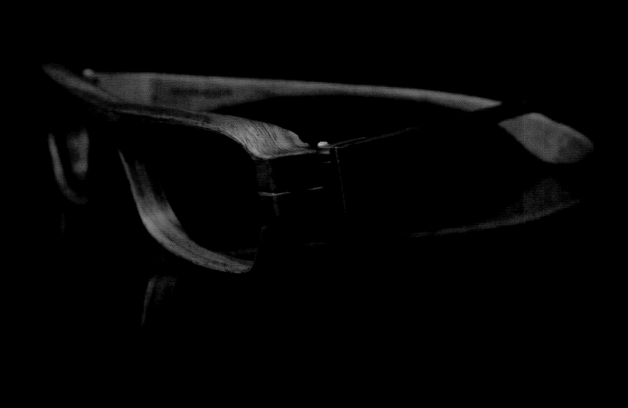

Herrlicht

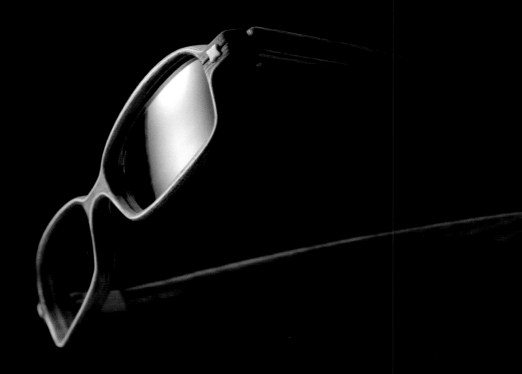

Herrlicht

glasses designer

Mykita

http://www.mykita.com

Mykita was founded by Harald Gottschling, Daniel Haffmans, Philipp Haffmans and Moritz Krueger in autumn 2003. Although the name might sound Asian, it was actually inspired by the firm's first premises: a former day care centre for children (in East Germany abbreviated to 'Kita').

A year later Mykita Collection No. 1 was introduced, an evolutionary step up in the world of eyewear both in terms of design and exclusivity. Technical innovations are key to Mykita products and all collections are based on patented hinge technology. In 2009, a new hinge for acetate was launched, based on metal-injection moulding, enabling a temple with a flex-hinge effect.

All frames are hand-made at the Mykita Haus, Mykita's office and production site in the heart of Berlin. And it isn't just production. At the Mykita Haus, we do everything from design to marketing and PR all under one roof. Mykita's design philosophy is based on the following key elements: 'visible technology',' technology as branding' and 'beauty meets technology'. In 2007, this design philosophy was used to create the first Mykita shop.

Mykita began collaborating with other brands and designers in 2006, starting with Berlin make-up brand USLU Airlines and followed by a collection with fashion designer Bernhard Willhelm. Collaborations are an important and fun part of the Mykita brand; the exchange of ideas with designers with a fashion perspective is always enriching. Mykita has recently worked with Marios Schwab, Herr von Eden and Romain Kremer.

100

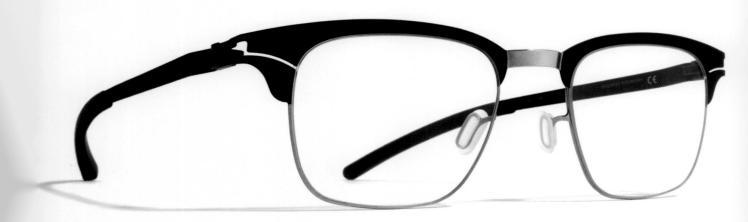

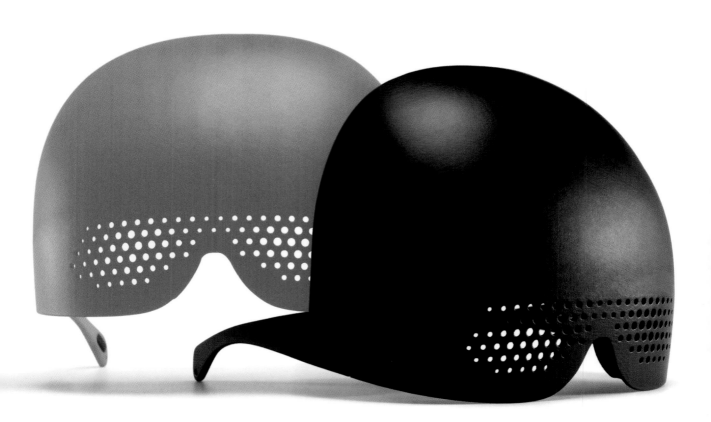

glasses designer

Theo

http://www.theo.be

Belgian eyewear brand Theo is internationally known for its distinctive designs which are available in some of the most prestigious shops in the world. The numerous prizes won by the brand include the Belgian Henry van de Velde design prize and the prestigious Silmo d'Or, proving that the Theo approach is a good one.

'We never started making glasses to get rich', explains Wim Somers, big boss and founder of Theo. 'Even after 20 years this isn't our main goal. We choose our own course and prefer exclusivity. To be faithful to our signature style is of the utmost importance. We would rather work with ten good points of sale than have a point of sale on every corner, in every city, just to make money'.

Over the years Theo has created an extensive range of striking frames. A modern design with a dash of humour is typical of the main Theo line. Eye-catching frames, flashy colours; they have the works. The eye-witness collection is characterised by more avant-garde designs. These models are usual asymmetrical, just like the human face. Then there is VinG-tage, launched when Theo turned 20. These glasses are inspired by the acetate glasses worn by Buddy Holly and Roy Orbison but have a metal frame with a synthetic look. The glasses are not remakes of previous models: it is all about the

mix of vintage and contemporary design. For their sunglasses collection, Theo is collaborating with Belgian designer, Tim Van Steenbergen. 32 year old Tim is a rising star in the fashion world. His work can be found in exclusive boutiques in Russia, the USA and Japan.

'We do follow fashion trends but we interpret them our way so the frames retain the Theo look. Our aim is to be different from other brands. We see our glasses as make-up for the face. Our frames support the character of the wearer but do not determine it. Theo loves you: we do not want to change you. We just provide a way of expressing who you really are'.

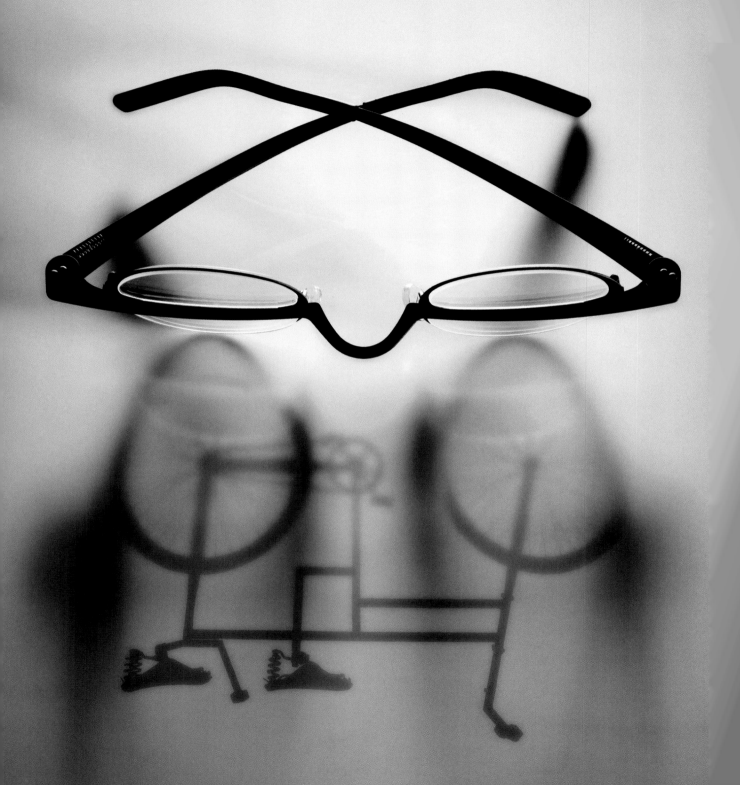

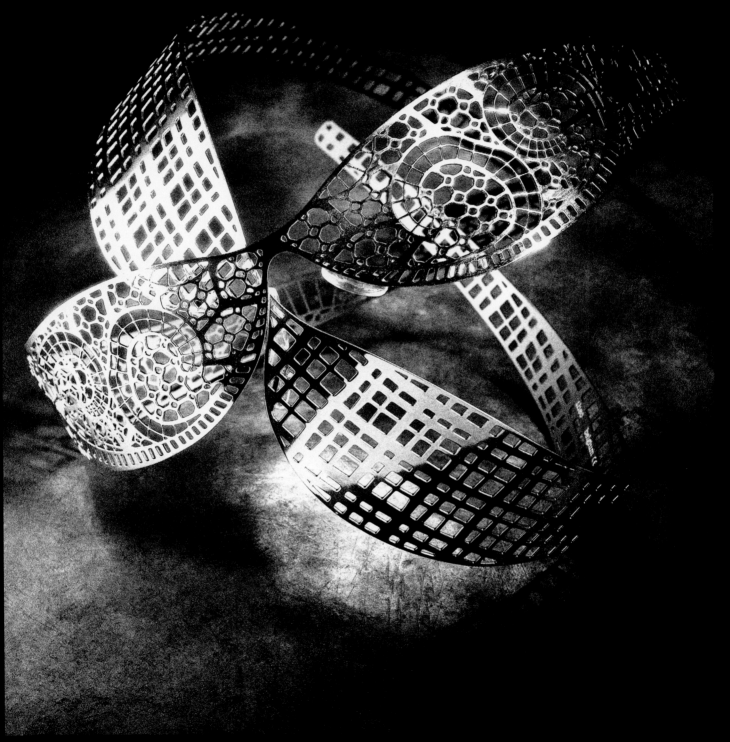

Theo EyeWMESH02

hats

hat designer

Federica Moretti

http://www.federicamorettihandmade.com

Federica Moretti's passion for art and style is the inspiration behind her work. Using her range of interests, she diversifies her style through the prism of different cultures, giving space to her eclecticism and uniqueness in the creation of fashion accessories. Her debut collection immediately attracted the attention of many different designers and fashion magazines. Moschino, Mila Schon, Giuliano Fujiwara, *Glamour*, *Vogue* and *Vanity Fair*, are just some of the brands and magazines that asked for Federica Moretti's input in their editorial shoots and fashion collections.

Federica Moretti's hat collections distinguish themselves by a combination of creative and original design, clever choice of fabrics and Italian craftsmanship. Careful study of shape has encouraged her to mix different shapes, obtaining new and surprising forms in the process and allowing each hat to have multiple uses.

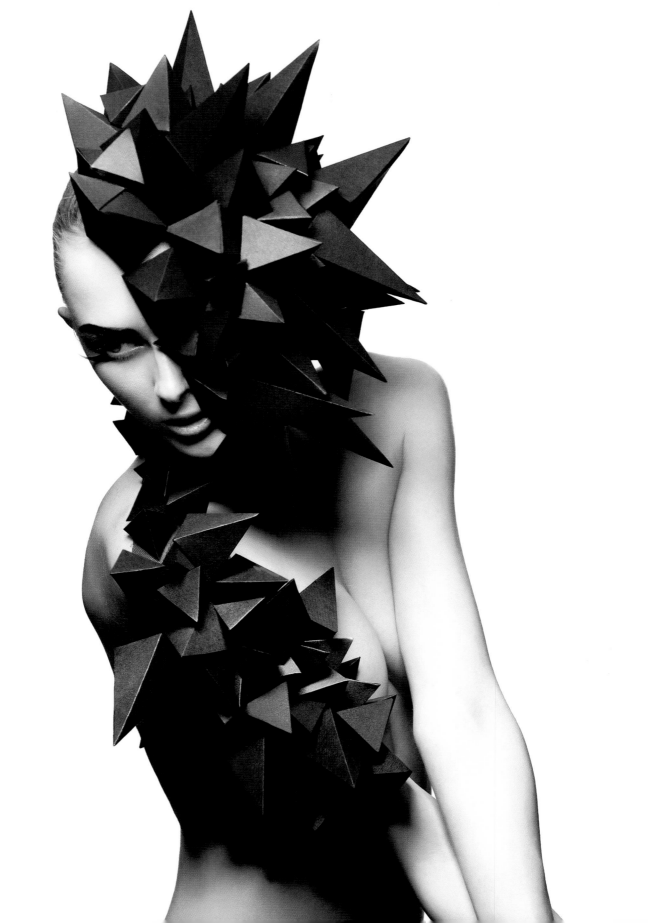

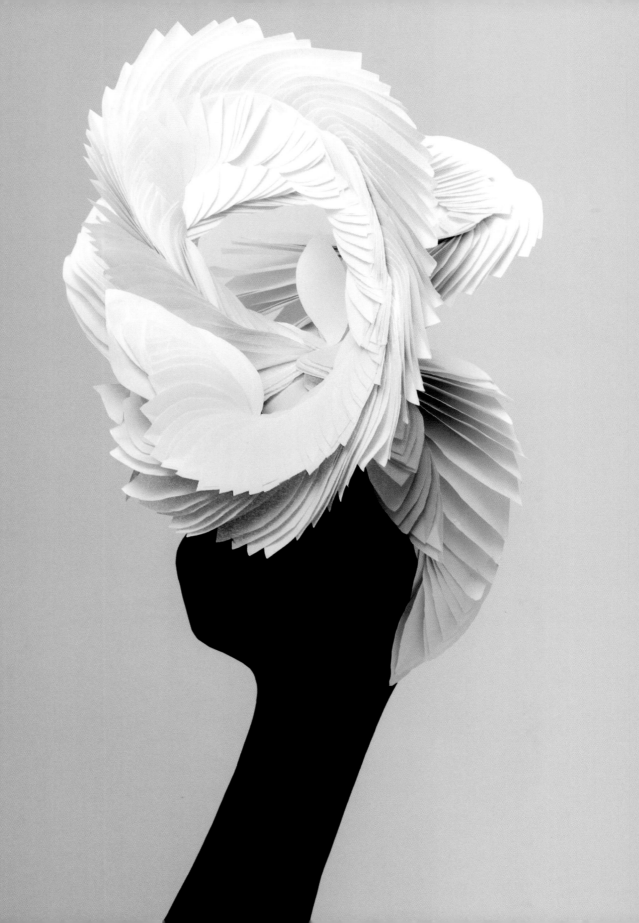

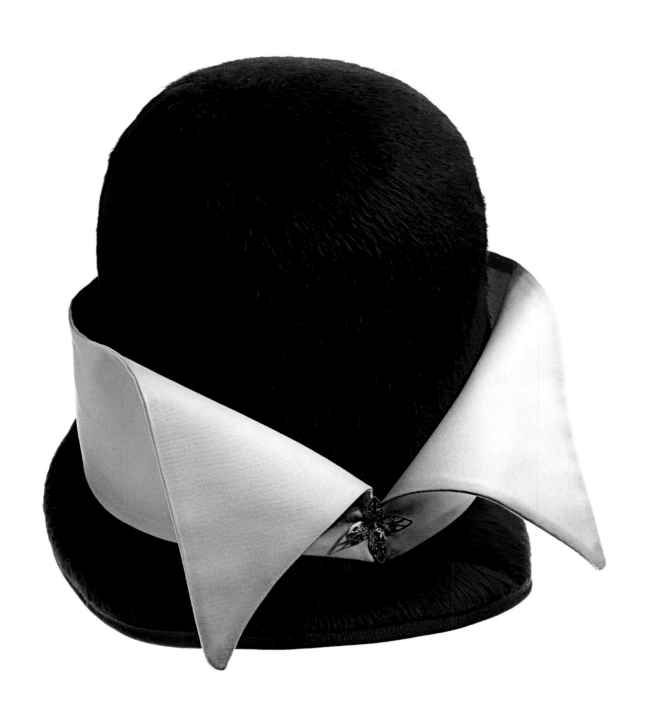

hat designer

Gigi Burris

http://www.gigiburris.com

After graduating from Parsons School of Design Fashion BFA programme last year, my millinery business grew organically from the interest in the couture hats I created to accompany my spring 2010 senior thesis collection. It was clear that there is a need for a new voice in the world of luxury headwear, and my passion for millinery and spooky, sophisticated perspective seemed to be the perfect recipe. Since then I have shown a second collection which focused specifically on headwear, and have collaborated with a number of designers and the NYC vintage landmark, Screaming Mimi's.

I am constantly inspired by the surreal and the dark side of femininity. My spring collection, which included ready-to-wear, was based on a fragile, decaying swamp. The hats were pastel flowers and straws with black feather detailing, and the ready to wear incorporated glossy black alligator. My autumn 2010 millinery range was inspired by witches, Fifties housewives and the circus. The palette was blue, black, navy and caramel, and included rhea whip feathers, bows, veils and horsehair.

The design process for hats is differs from ready-to-wear, as it is not completely centred around a concept. The material, the block shape and the trims come together almost naturally. I love nothing more than sitting in my studio sur-

rounded by trims, materials and inspirational images. One of the things that really drew me to millinery is the romance around the craft. It is such an old and beautiful tradition and I love the fact that legends such as Chanel and Lanvin also started as milliners.

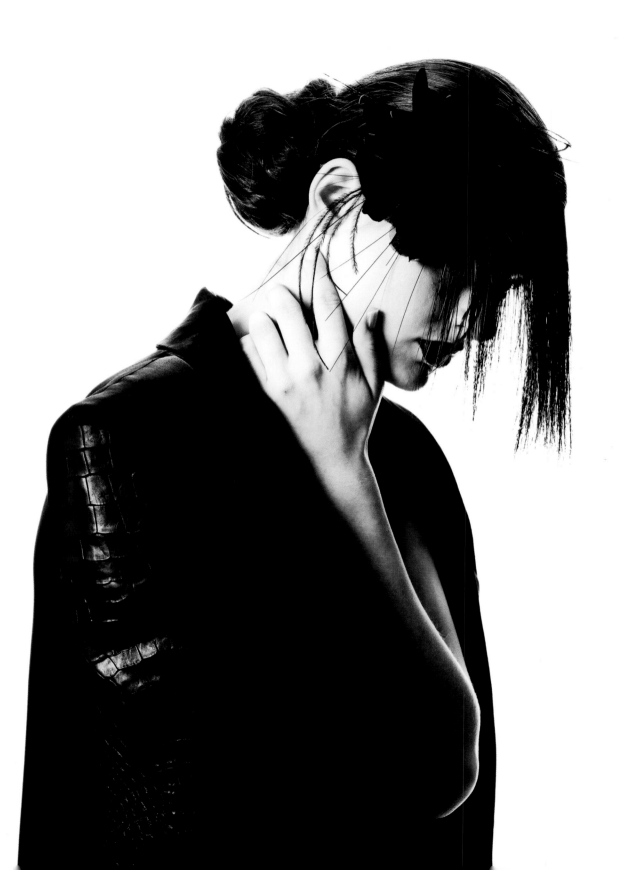

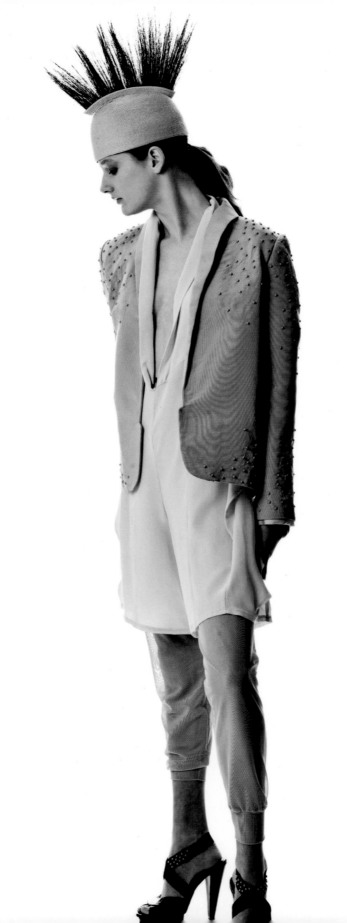

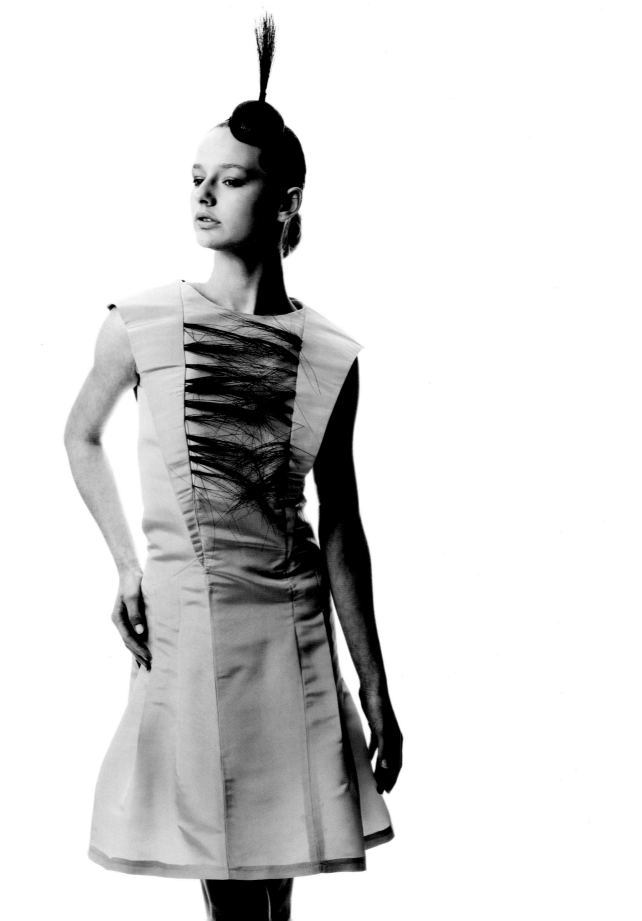

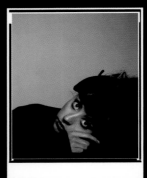

hat designer

Julia Cranz

http://juliacranz.com

Julia Cranz has been drawing and designing all her life while fashion, style and design have always been her passion. Her career was probably mapped out before she was born. There was the Vienna Hetzendorf fashion school where she initially studied fashion design and later millinery as part of the Fashion Designing and Tailoring course

A small detour into agricultural economics, in which she had professional training doesn't fit the simple career path. She sees it differently, though Her relationship with nature, natural materials and animals is the basis of the artist. 'Nature, its shapes, colours, textures and their countless combinations and interactions are an important source of inspiration for me,' she says.

Isabella Blow, discoverer and muse of many great fashion designers and models, including Alexander McQueen, Philip Treacy, Sophie Dahl and Stella Tennant, came to see the collection, gracefully moved through the studio and chucked most pieces into the corner accompanied by an expletive. But at times, she shouted 'great' or 'that's something' and after a two-hour long gin and tonic session, accompanied by an impassioned discussion, Julia knew exactly where she wanted to go. From that point on, nothing has stopped her.

Julia Cranz travels a lot, collects impressions and new materials, searches markets, learns new techniques and works for theatres and film productions in Germany and Austria. Meetings with graffiti artists influence her work as did an excursion into the fetish scene, to which she has dedicated a complete collection.

Julia Cranz, a self-described workaholic, spends every available minute in one of her studios, designing and producing hats by hand. This is probably exactly what her clientele appreciates so much: the combination of art and craftsmanship in each of her extravagant creations, all of which are wearable and never look excessive or ridiculous.

Her clientele could not be more diverse. Among others, Julia Cranz has created pieces for opera diva Anna Netrebko and Mieze, the punky lead singer of German group Mia.
'This is what I like the most about creating hats', says Cranz. 'Each customer is different and they have their own ideas so I have to accommodate everything. This way, there are no limits to my imagination.'

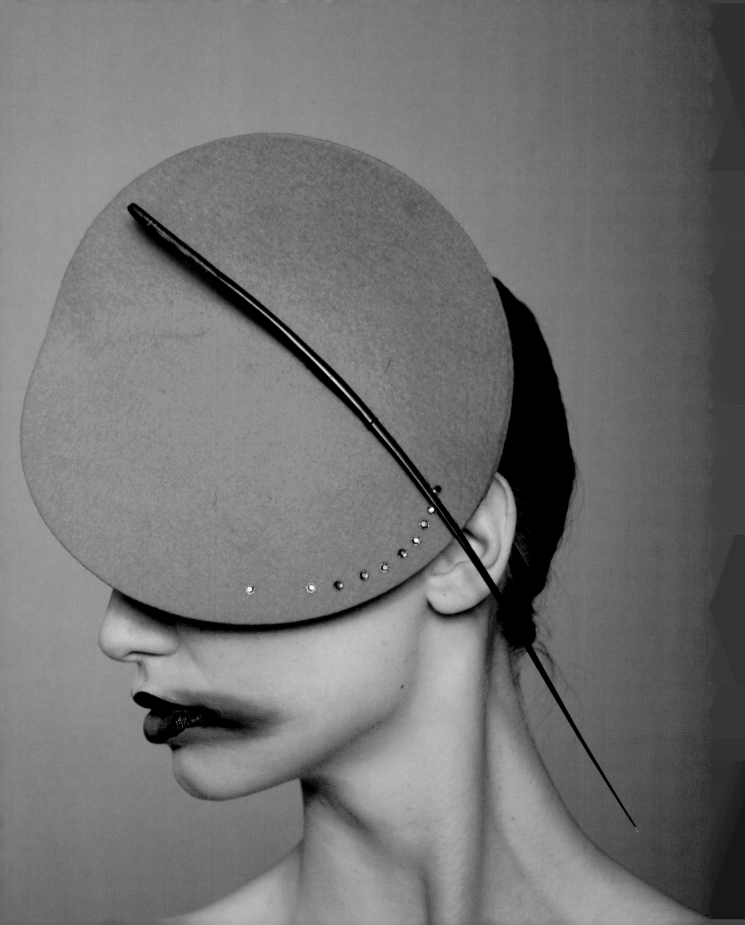

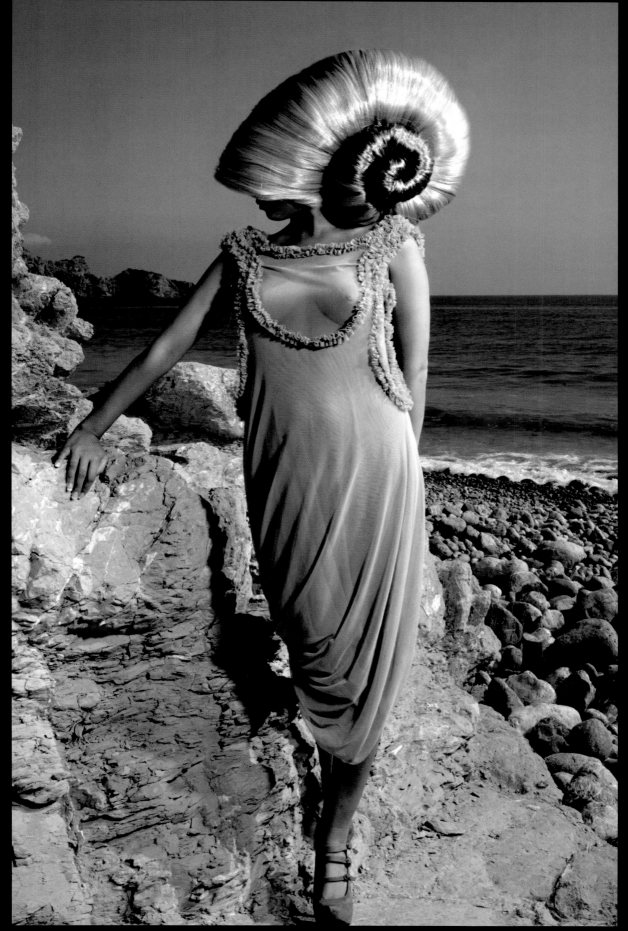

Cranz Kurrukurru Muschel

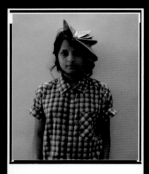

hat designer

Little Shilpa

http://www.littleshilpa.com

Designer, Shilpa Chavan has worked as a stylist for magazines, music channels, ad campaigns as well as films. She has collaborated with Indian designers such as Manish Arora, Tarun Tahiliani, Sabyasachi Mujherjee, Hemant Trevedi, Wendel Rodricks and Malini Ramani as well as British labels Boudicca, Unconditional and Javier Salvador. She also works as an installation artist and her work has been exhibited in France, London, Barcelona and India. For her own label, Little Shilpa, she has been designing accessories, turning her installations into wearable pieces for runway shows, editorial or fashion shoots, and ad campaigns.

The inspiration for Little Shilpa comes from travel and interaction with different cultures. It takes shapes and juxtaposes them with fabric, trimmings, metal and acrylic. Little Shilpa creates this co-existence by combining the past with the present, and decadence with clean and simple design. Her head pieces are like a canvas, as they personify an aspect of her visual influence from observation to execution. Shilpa is currently based in Mumbai, designing and handcrafting one-off pieces for retail and runway shows.

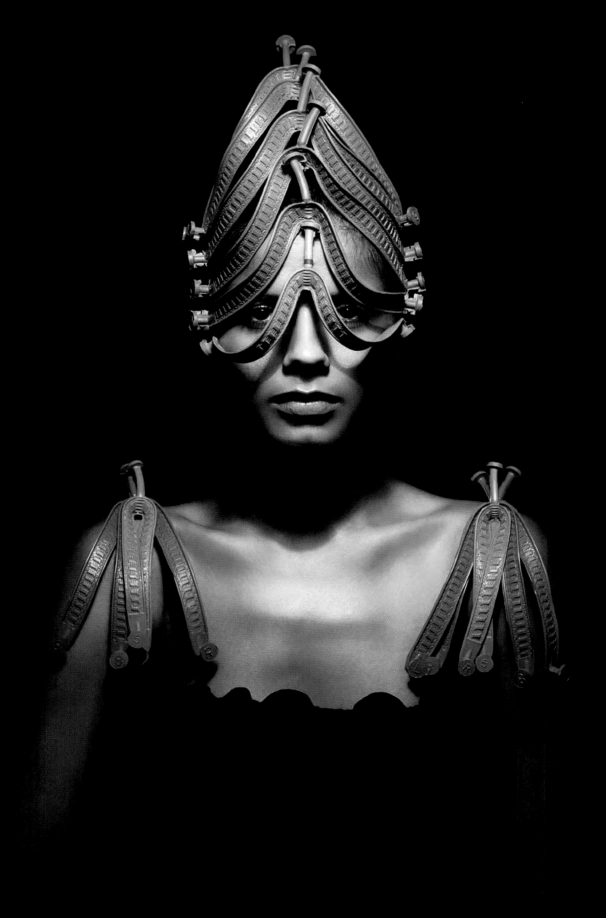

Little Shilpa 2-048272

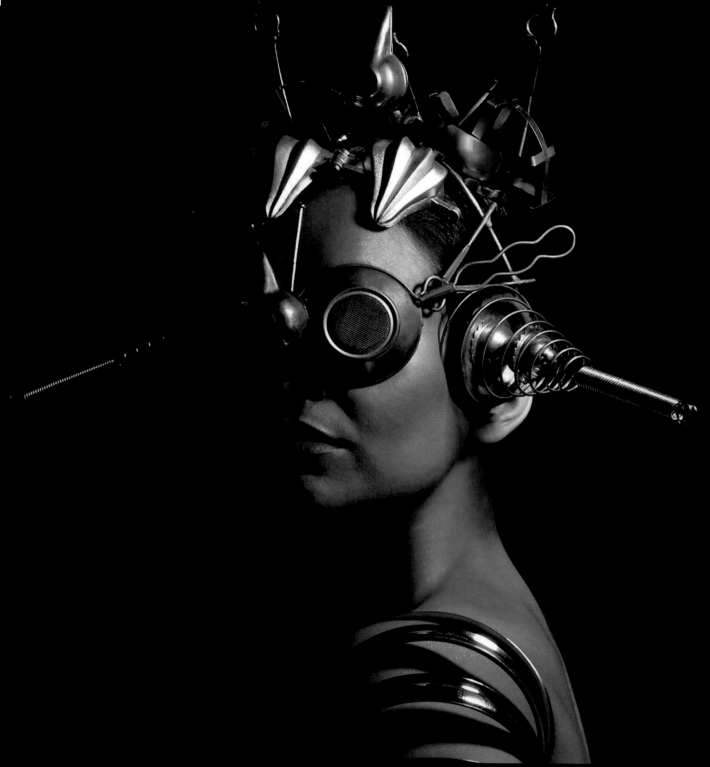

Little Shilpa Ufo Steel

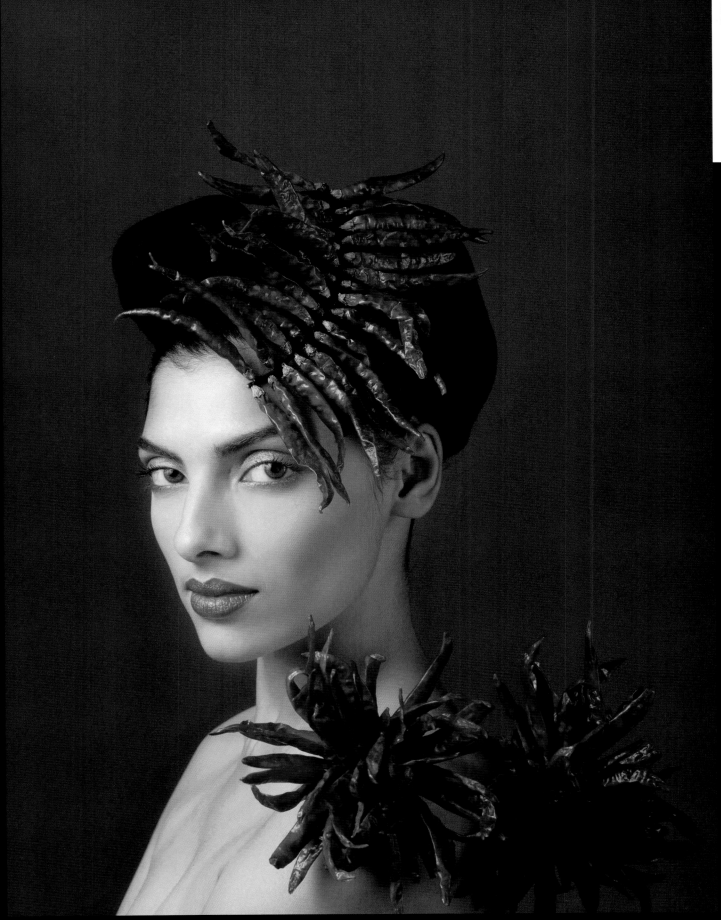

Little Shilpa Pokarna Indrani

hat designer

Louis Mariette

http://www.louismariette.co.uk

Louis Mariette was born in Malawi. He grew up in Botswana and Swaziland where nature was his playground and he spent many an hour exploring the two countries' endless species of flora and fauna which gave him a passion for colour and sparkle. He would collect semi precious stones, seedpods, cactus flowers, and beads and trimmings from local tribes. He was mesmerised by bird feathers, such as an explosion of iridescent colours from a lilac breasted roller as it darted after prey. Louis also recognised the incredible palette of colours and textures to be found in beetles, butterflies and dragonflies — a dazzling assault on his senses. Such depths of curiosity and inspiration are brought to life through his designs today.

Louis' talent, charisma and *joie de vivre* have captured the imagination of designers, photographers, stylists and creative directors alike. His creations are worn by an eclectic clientele including glamorous celebrities such as Jerry Hall, Alek Wek, Jodie Kidd, Sophie Dahl, Lisa Butcher and Isabell Kristensen.

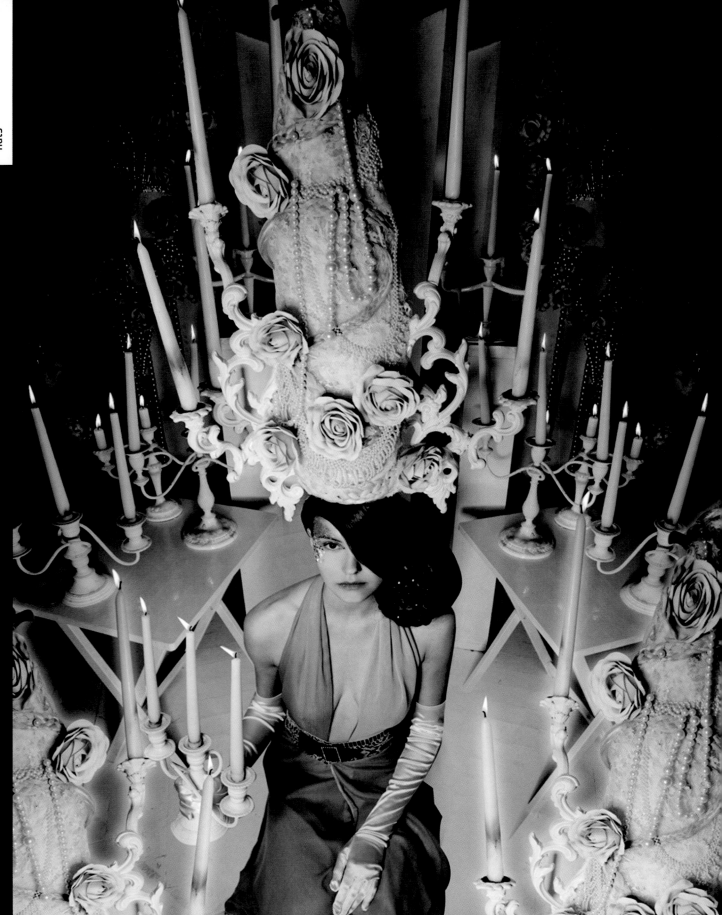

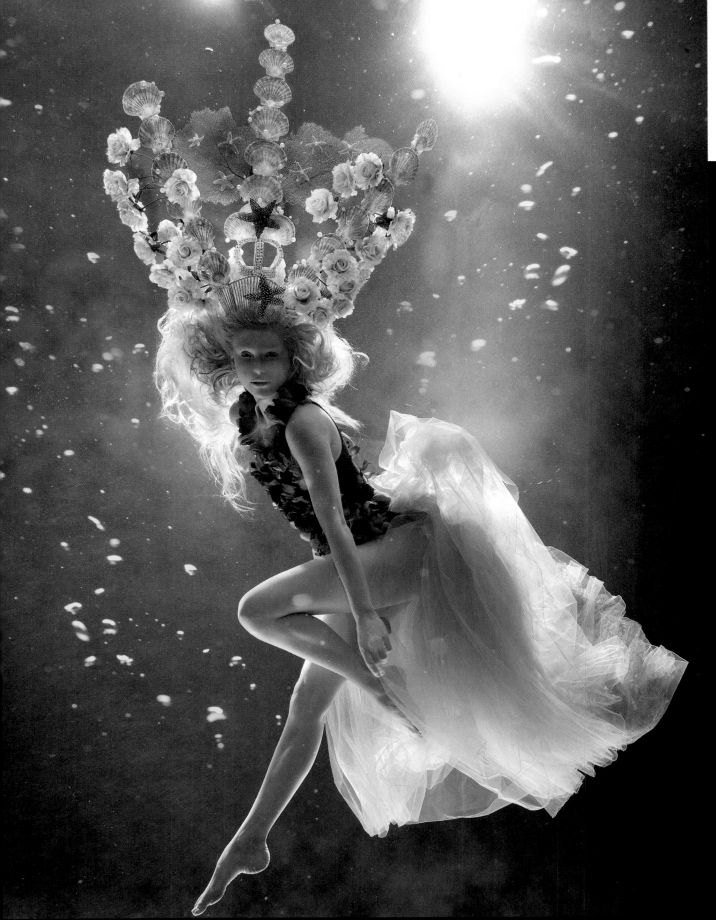

Louis Mariette Princess Neptune

hat designer

Piers Atkinson

http://www.piersatkinson.com

Piers Atkinson has worn nearly as many hats as he's made. Artist, illustrator, milliner, costume designer, party organiser, fashion editor and project manager: his creative energies seem to be matched only by his insatiable curiosity.

He grew up in Norfolk with three generations of women — his mother, also a milliner; his sister Lucy, the long-suffering model for his teenage reconstructions of Grace Jones and Art of Noise record covers; and his grandmother, the artist, writer, horticulturalist and illustrator Lesley Gordon, from whom he took his multi-disciplinary cue.

Piers has had many great influences down the line, from his mother the theatrical milliner Hilary Elliott, at whose knee he learned hat-making, to Stephen Jones, who paid a brief but memorable visit to his graduate show at the University of Bristol, where he studied graphic design and photography.

Moving to London in 1995, he helped out at that year's Alternative Miss World, the brainchild of artist Andrew Logan, now an occasional collaborator but constant inspiration to Piers: 'He helped me see the rich possibilities of free-form events and a just-do-it attitude.'

In 1999, Piers started working with iconic fashion designer Zandra Rhodes, who he assisted with art direction and in-house PR. 'She instantly cured my conservative approach to colour!' says Piers. When Rhodes became a client of PR powerhouse Mandi Lennard, Piers took a post there assisting Mandi, who gave him a unique insight into the fashion world. After a similar stint at Blow PR, he joined *Disorder Magazine* as fashion editor for a shelf-full of issues. It was in this capacity that he proposed the idea of a newspaper for Graduate Fashion Week, featuring a star column by the *Daily Telegraph's* fashion director, Hilary Alexander. This later led to Piers creating the daily for London Fashion Week (bringing in *Teen Vogue's* Jenny Dyson as co-editor), an intense and rewarding experience. One of the rewards was the small range of hats he created during this time to 'let off steam' — a range that became his debut collection. He has since collaborated with designers Ashish and Noki for runway presentations, has pieces in the V&A's 'Hats: an Anthology by Stephen Jones' and has dressed celebrities Cate Blanchett in *Vogue* and Lily Allen in *Spin Magazine*.

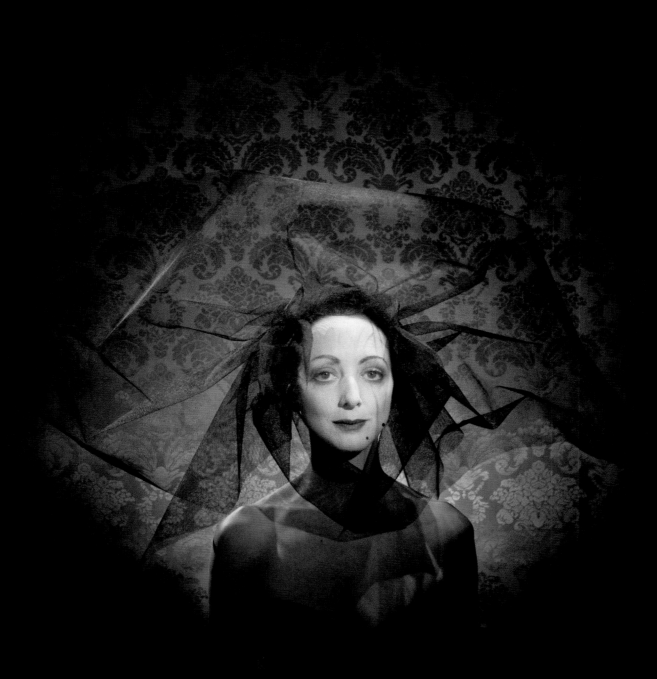

Piers Atkinson © Thomas Lohr

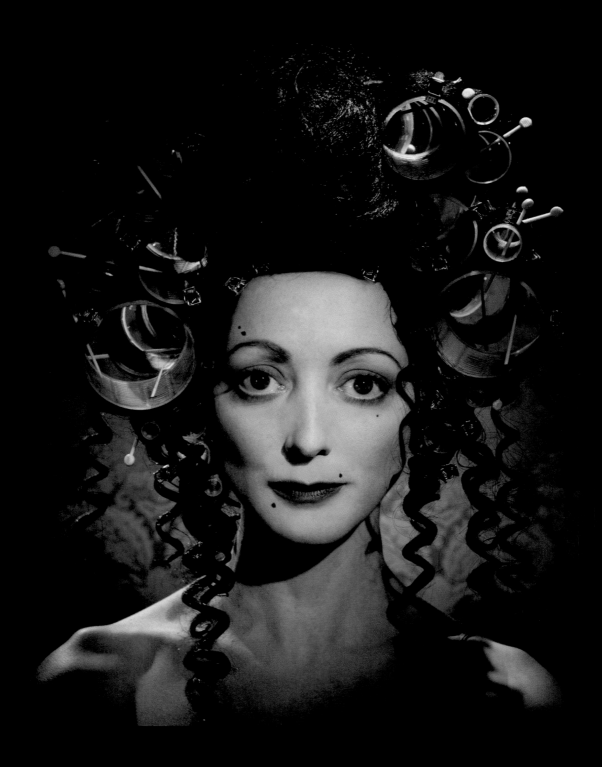

Piers Atkinson © Thomas Lohr

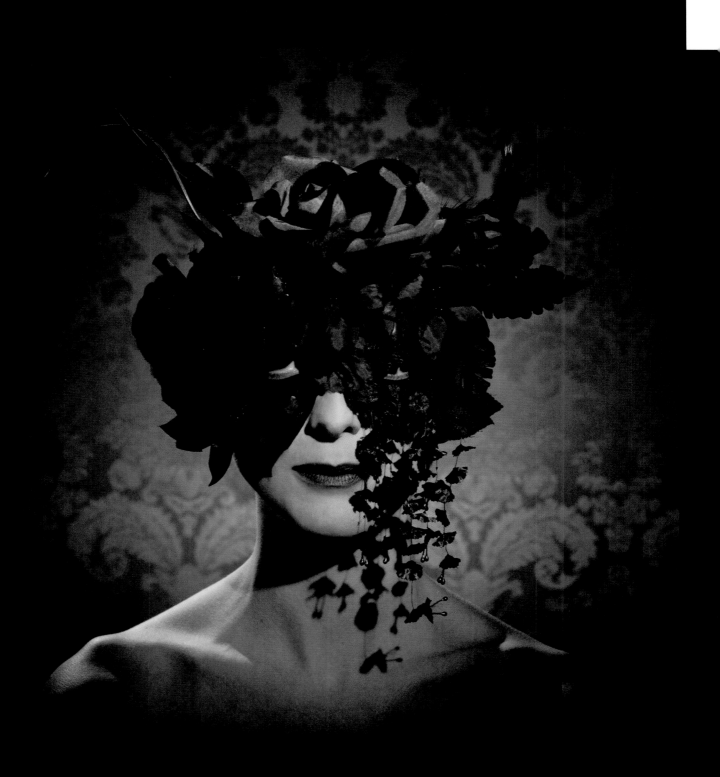

Piers Atkinson © Thomas Lohr

hat designer

Stephen Jones

http://www.stephenjonesmillinery.com

'Stephen Jones is the maker of the most beautiful hats in the world', says Anna Piaggi of Italian *Vogue*.

Stephen Jones burst on to the London fashion scene during the explosion of street style in the late seventies. By day, he was a student at St Martins; after dark he was one of the decade's uncompromising style trail-blazers at the legendary Blitz nightclub – always exquisitely dressed, and always crowned with a striking hat of his own design.

By 1980, Jones had opened his first millinery salon in the heart of London's Covent Garden. The premises soon became a place of pilgrimage and patronage, as everyone from rock stars to royalty, from Boy George to Princess Diana, identified Jones as the milliner who would help them make arresting headlines. Jones made millinery seem modern and compelling. In materials that were often radical, and in designs that ranged from refined to whimsical, his exquisitely crafted, quixotic hats encapsulated the fashion mood of the moment.

Thirty years later, Jones's era-defining edge continues to attract a celebrity clientele which currently includes Marilyn Manson, Pink, Gwen Stefani, Beyonce Knowles and Alison Goldfrapp. Ever playful with scale, Jones created Kylie Minogue's truly spectacular showgirl headdresses while for Dita

Von Teese, the burlesque super-star, he recently fashioned the tiniest of tricornes. He has designed hats for the Rolling Stones and for Rei Kawakubo's recent Stones-inspired Comme des Garçons menswear collection.

Jones's hats have been an integral component in some of the most memorable runway spectacles of the past quarter century. From Vivienne Westwood, Claude Montana, Thierry Mugler and Jean-Paul Gaultier throughout the eighties to his current work with John Galliano for Dior,

Today, Jones's retail boutique, design studio and workroom are all located in a charming Georgian townhouse close to the site of his very first boutique. In addition to his Model Millinery collection, he designs the widely-distributed Miss Jones and Jones Boy diffusion ranges, plus a Jones Girl accessories line exclusively for Japan.

Jones's work is represented in the permanent collections of the V & A, the Louvre, The Fashion Institute of Technology and the Brooklyn Museum in New York, the Kyoto Costume Institute, and the Australian National Gallery. Now, as ever at the forefront of fashion, his beguiling hats grace the most celebrated magazine covers and enliven the window displays of the world's most stylish stores.

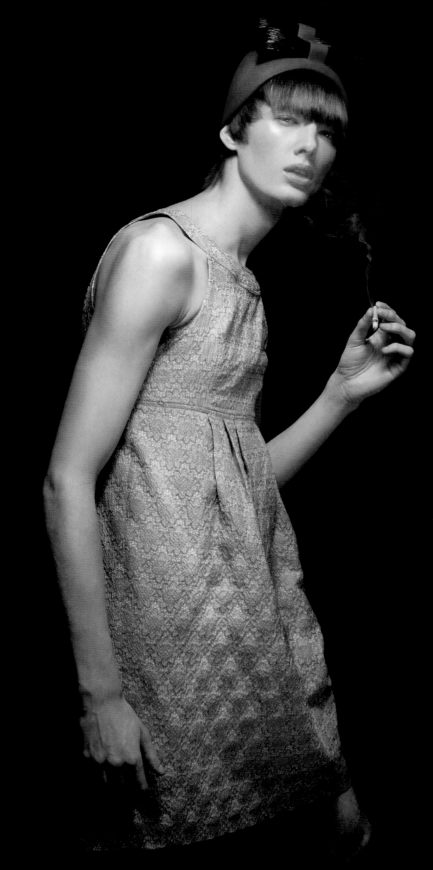

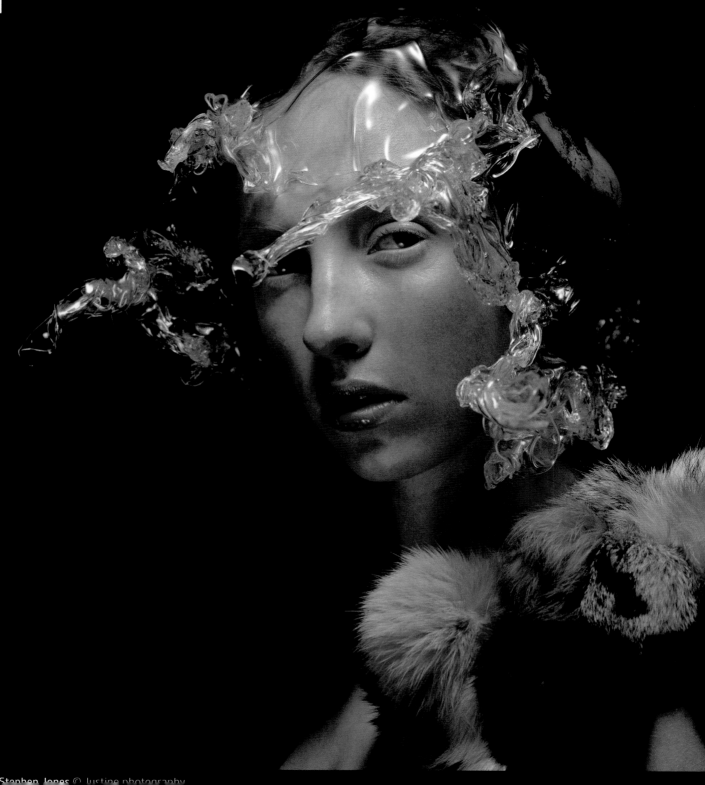

Stephen Jones © Justine photography

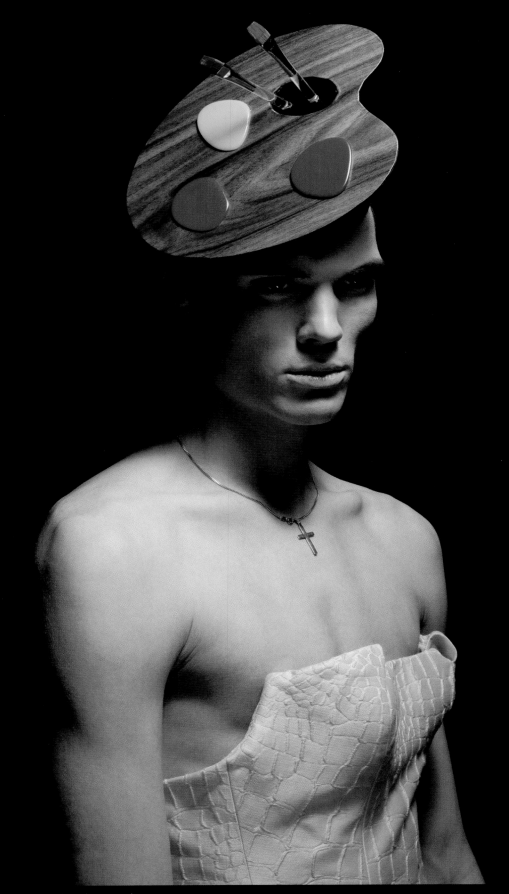

Stephen Jones © Justine photography

shoe designer

Alain Quilici

http://www.alainquilici.com

Born in Tuscany to a family of cobblers, Alain Quilici has been designing his eponymous shoe collection for two years. He plays with form and function before adding an unexpected third element. The formula is form follows function follows vision.

Alain Quilici has built his particular aesthetic relying on inspirations as diverse as the flesh and metal hybrids of Shinya Tsukamoto's post human cinema, the physical and psychological deformations of David Cronenberg's movies and the muscular drama of Francis Bacon and Egon Schiele's paintings. Transformation, morphing and evolution are constant themes in his oeuvre. No longer mere accessories, shoes turn into foot suffix that organically extend and redefine the body, creating a new, seductive anatomy.

Forms are often questioning, always incisive, never frivolous: design follows a rigorous determinism that makes sure that every element goes through an evolution process. The mechanical transformation takes off from a well-known starting point to reach unexpected results. The silhouette of a roller or ice skate, for instance, spawns a fetishistic bootie; a wedge torn apart generates a stiletto heel; a sturdy heel hides a slim metallic blade. Elsewhere, a heel turns into a curvy, menacing drill; vertical cuts on a platform suggests joints on a con-veyer belt; a wedge heel gets an angular silhouette, as if it is creating its very own limits. To highlight the rigour of the composition, colours are generally limited to a strict palette of graphic black and white, grey and flesh-toned neutrals.

Alain Quilici's vision of the future is a decayed and consumed one. His post-human post-design does not forsake the seductive power that has always been associated with shoes; it simply alters its DNA from the inside.

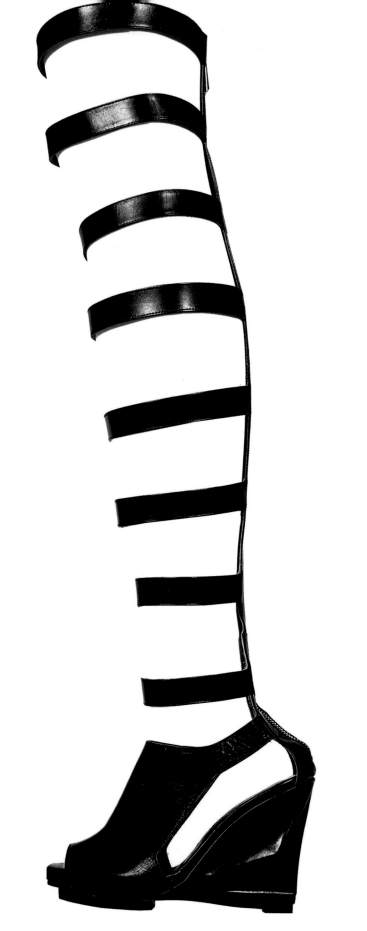

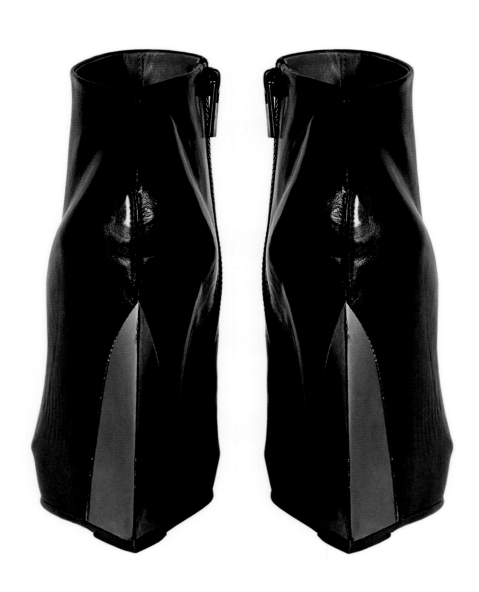

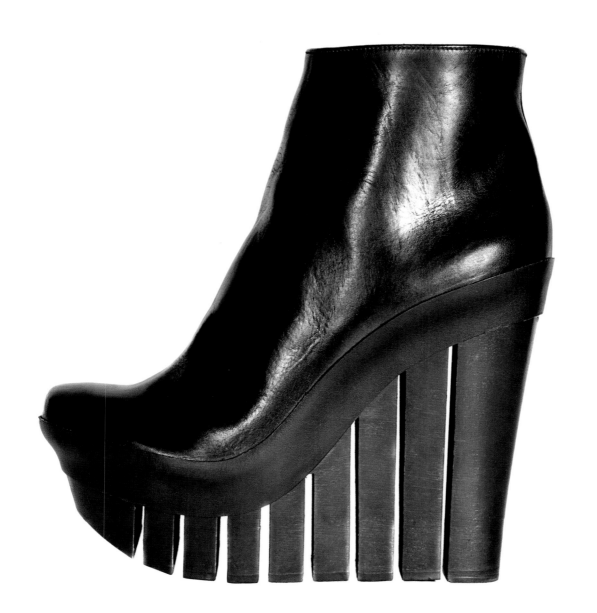

shoe designer

Andrew McDonald

http://www.andrewmcdonald.com.au

I have been designing and making shoes by hand for 20 years in my workshop in Sydney, Australia. We produce approximately four to five hundred pairs of shoes every year, which we sell all over the world. The footwear we make refutes the mass production logic. Every shoe and accessory is a unique item, brought to life by the shoe and its possessor. A passion for leather and tradition has inspired the materials and processes used to make our shoes. We spend a lot of our time investigating and researching every aspect of the materials, make, design and fit which enables us to create shoes that transcend the vicissitudes of time. We make shoes for those who want something unique.

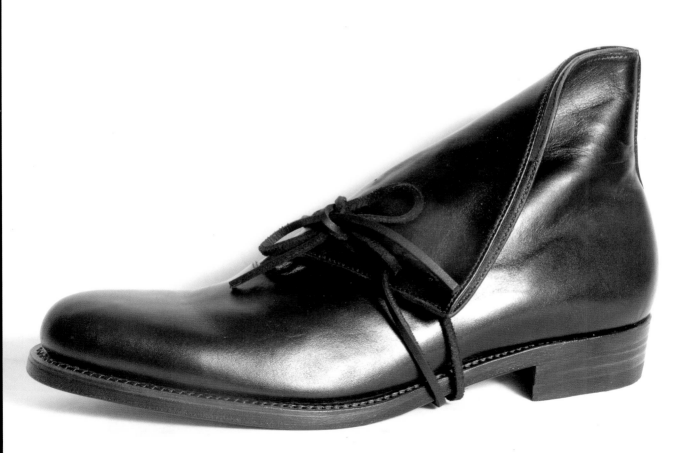

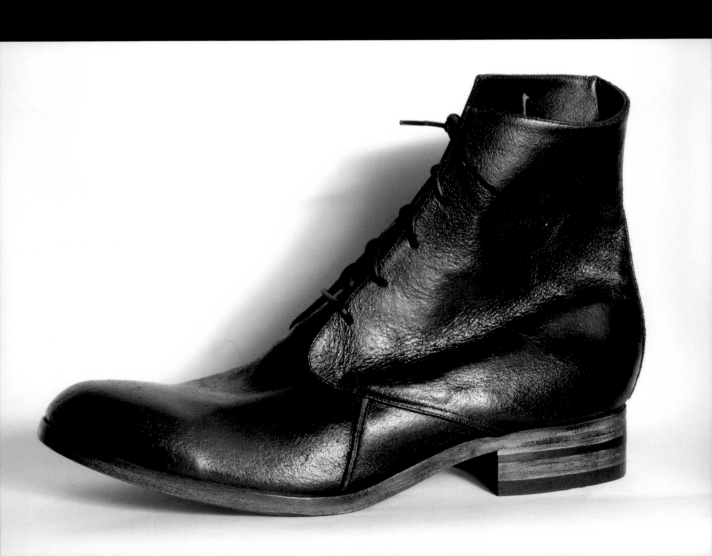

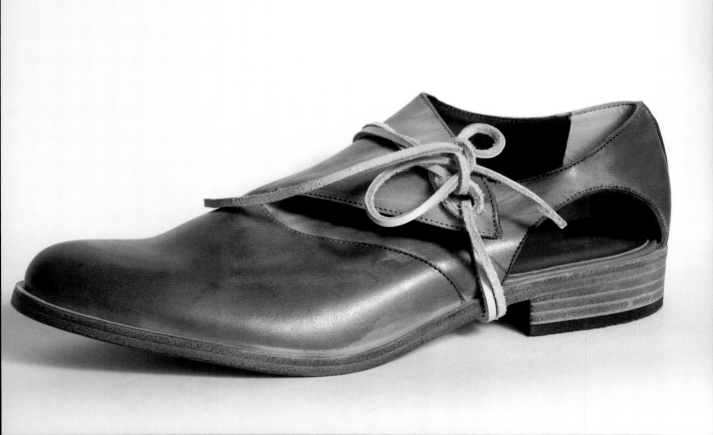

shoe designer

Atalanta Weller

http://www.atalantaweller.com

Bold dynamic shapes, a strong sense of colour and sharp graphic lines are all signature elements of Atalanta Weller's designs. Her second collection, Autumn/Winter 2010, was awarded the prestigious British Fashion Council New Gen award.

Atalanta's vision blurs the line between real and imaginary, natural and artificial, strength and subtlety. Inspired by the CGI superheroes of cult animé series, Appleseed, and the concrete illusions of modernist architect Pierre Luigi Nervi, her collections aim to challenge preconceptions and open the eyes to new possibilities.

'I want my shoes to look and feel different, so the women that wear them stand out from the crowd. Having gained experience through working with many different companies in the footwear and fashion industries, I like to use new technology within the shoe, combining materials and new techniques to create ground breaking designs that won't ruin the wearer's feet. Sculpture is one of my great passions: I love the idea of creating a range of shoes which people can buy, but which also stand as mini sculptures in their own right. I also create more conceptual pieces that really push the boundary between footwear and art.'

148

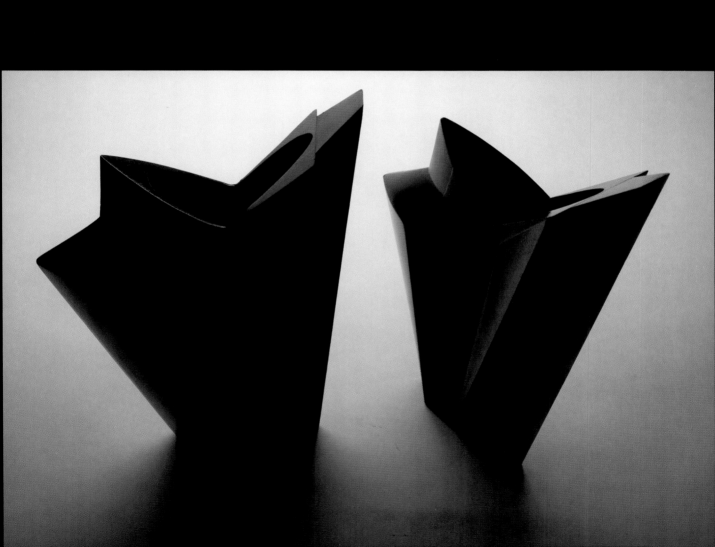

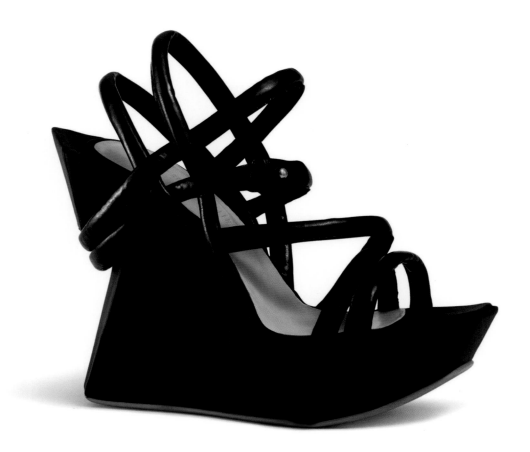

Atalanta Weller Scotty Black

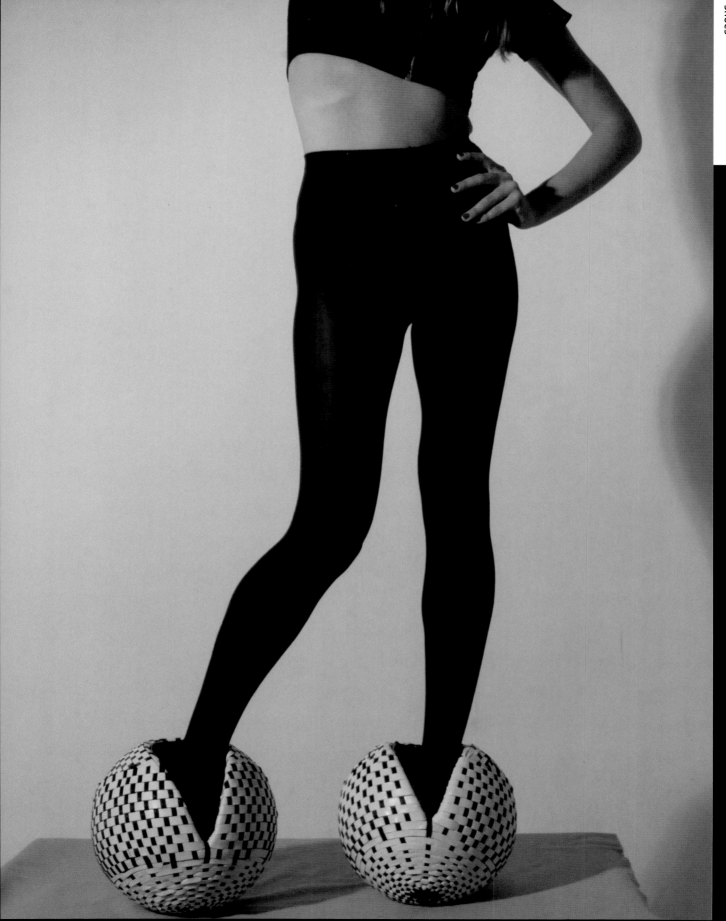

Atalanta Weller Balls

shoe designer

Augusta Shoes

http://www.augusta-shoes.com

Designer Simone Cecchetto launched the first Augusta Collection during Paris Fashion Week in March 2006. With a background in art and a passion for experimental fashion, Simone began his career working with the pioneers of avant-garde fashion but eventually decided to follow his instincts and form Augusta.

Augusta's approach is to create a totally handmade product, with great attention paid to detail and constant research into new methods of treating the materials used in the collections. All the materials used undergo a transformation during the creative process used to make the final object.

The shoe is the backbone of Augusta but in 2008, Cecchetto's interest in clothing the whole body, led to the addition of leather jackets to the collection.

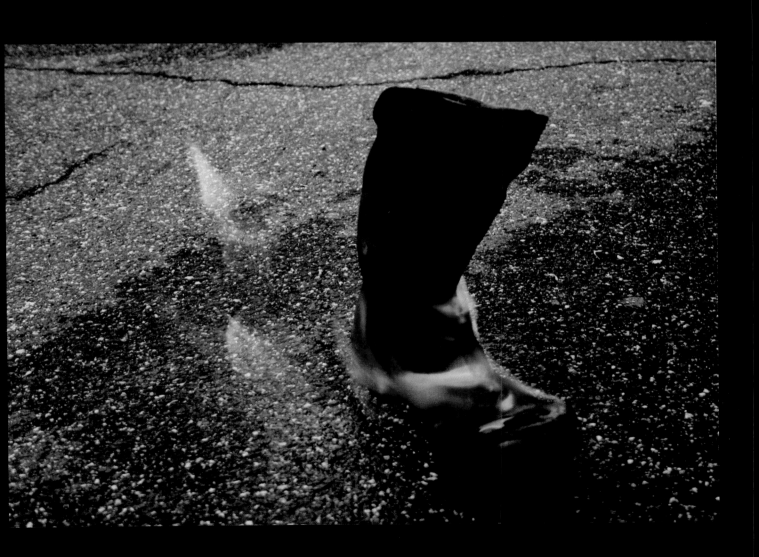

Augusta Shoes

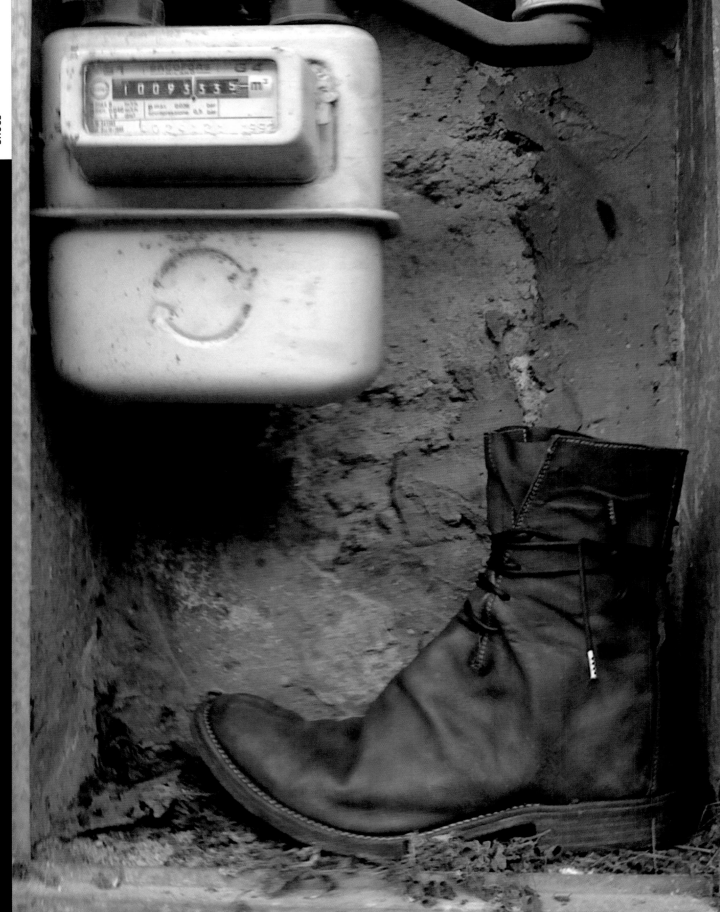

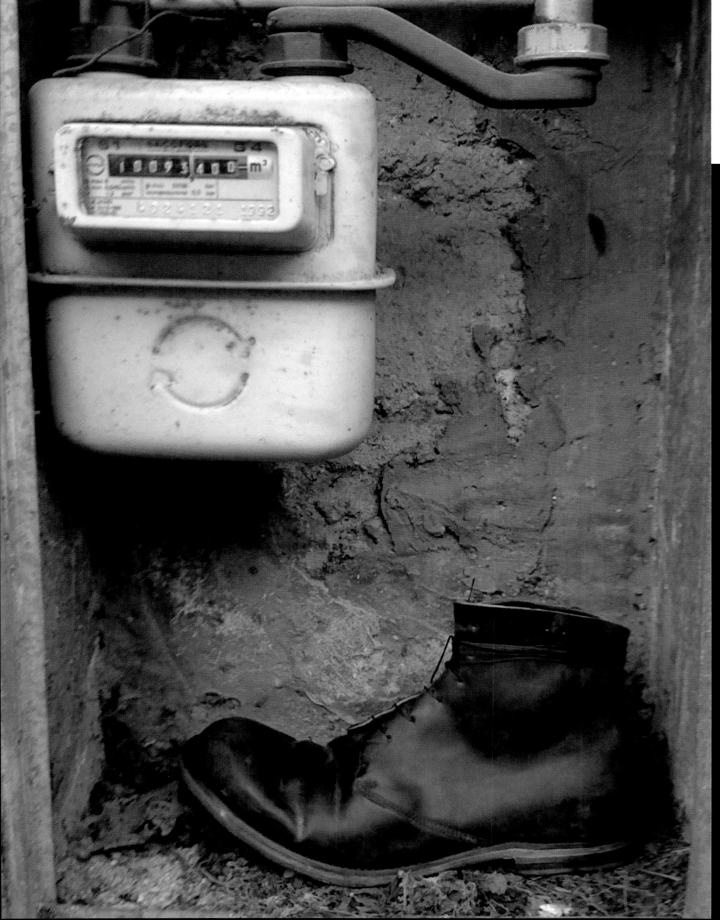

Augusta Shoes

shoe designer

Camilla Skovgaard

http://www.camillaskovgaard.com

Danish designer Camilla Skovgaard began her career in women's couture in Dubai at the age of 20 when a French-owned company brought her to the Gulf to design for the region's rulers' wives and daughters. After seven years in Dubai, Camilla moved to London in 2000 to study the craft of shoe making at Cordwainers College. She graduated in 2003 and continued her studies at the Royal College of Art before graduating for the final time in 2006. It was during her MA year that the seeds of her eponymous shoe collection were sown and Saks Fifth Avenue in the US bought her first collection while she was still a student.

Camilla was awarded the Queen Elizabeth Scholar Award for Excellence in British Craftsmanship 2007, and was voted Shoe Designer of the Year 2008 via a public vote on Australia shoe blog *Imelda*. Camilla was also nominated for the Swarovski Emerging Talent: Accessories prize at the 2009 British Fashion Awards and won the Accessories Designer of the Year award at the ELLE Style Awards in 2010. In addition to her own line, Camilla worked with British designer Matthew Williamson for seven seasons and continues to collaborate with some of fashion's best known designers.

Camilla Skovgaard shoes are gaining recognition for their fluid-edged style combined with high quality shoemaking. Her emphasis is on form, materials and style rather than decoration. The combination of contrasting elements such as fluidity and severity, restraint and sophistication, play an integral part in the character of her designs.

Camilla Skovgaard's shoes have been embraced by some of fashion's most influential editors and tastemakers including Halle Berry, Rhianna and HRH Princess Marie-Chantal of Greece. She currently has a customer portfolio which includes 130 wholesale accounts in 28 countries, including Saks Fifth Avenue in the USA, Harvey Nichols in London, Villa Moda in Dubai, Joyce in Hong Kong and Net-a-Porter.com. Camilla lives and works out between London and Hong Kong.

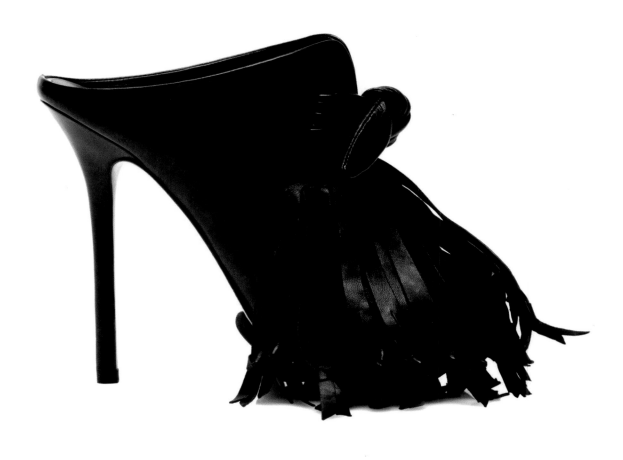

Camilla Skovgaard

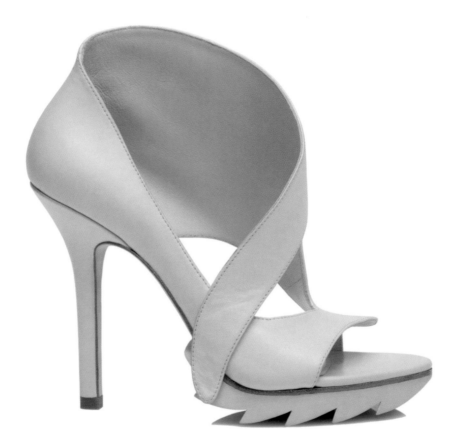

Camilla Skovgaard

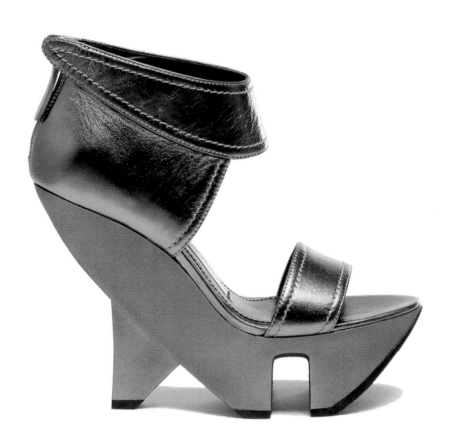

shoe designer

Guidi

http://www.guidi.it

In 1896, Guido Guidi, Giovanni Rosellini and Gino Ulivo established the Conceria Guidi e Rosellini in Pescia, Tuscany. Traditional leather work has existed here since the 14th Century when a guild of tanners and shoemakers was established.

Ruggero Guidi is running the Guidi tannery today and he expends his time and energy looking for the perfect balance between modern technology and respect for his heritage. The Conceria Guidi e Rosellini is now known all over the world and its most discerning designers come to Guidi for the special leathers and treatments their designs demand.

Passion for leather and respect for tradition are behind Guidi's shoe collection. Ruggero avoids mass production and is focused on his own research into creating shoes for those who want something unique with a traditional twist; shoes only a true craftsman could make. Available in soft hide or distressed, thickened leather, Guidi is synonymous with the tie between an object and its possessor, and the pleasure it can bring.

Guidi Wall'n'ground

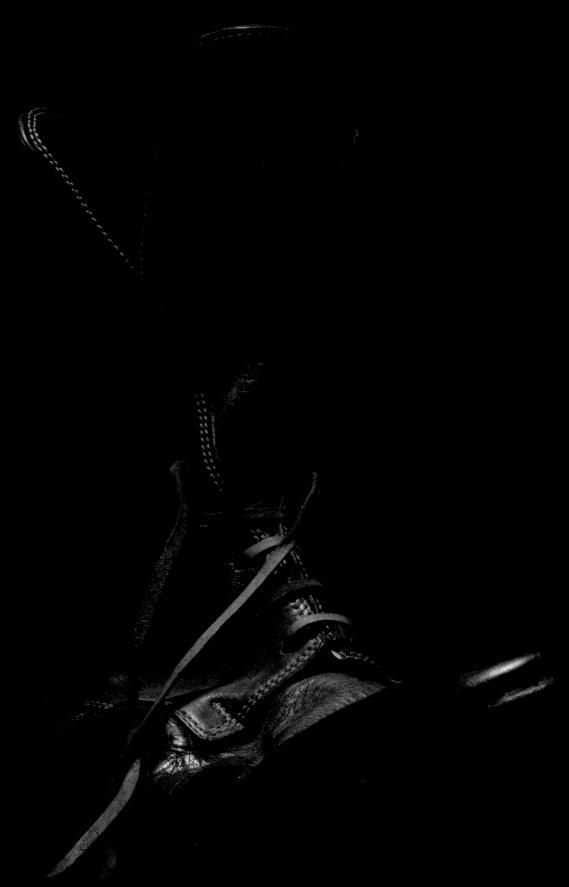

shoes

Guidi Black 01-21776

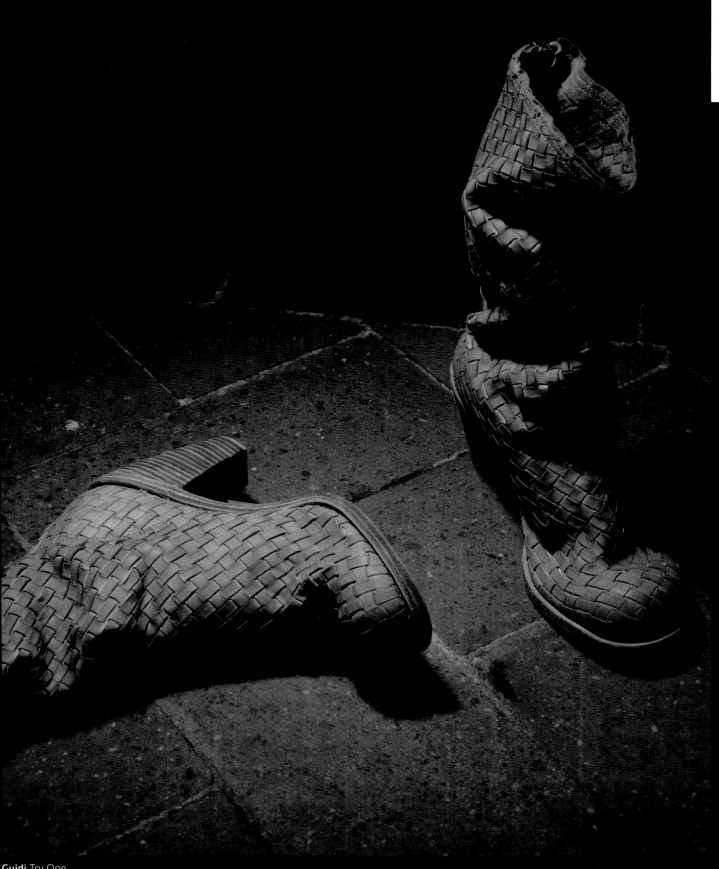

Guidi Try One

shoe designer

Kobi Levi

http://kobilevidesign.blogspot.com

Kobi Levi graduated from the Bezalel Academy of Art and Design in Jerusalem where he studied jewellery and accessories design. He now specialises in footwear. He also works as a freelance designer. Over the last five years, he has collaborated with Skins Footwear Inc and is currently working on his own men's shoe line in TelAviv. He has also developed industrial footwear in Italy, China and Brazil. His work can be seen in exhibitions in Tel-Aviv, Jerusalem, Tokyo, Verona, St. Etienne and Berlin.

'The impulse to create a new piece comes when an idea, a concept or an image springs to mind. The combination of the image and footwear creates a new hybrid and the design comes to life. Much of my inspiration is unusual and often the result is humorous and extraordinary. Another aspect of the creative process is the realisation of the design. All the pieces are made in my studio. Using challenging techniques is the key to bringing the design to life in the best way possible. When I design a shoe I think about it as a sculpture to wear, an art piece you can live with. You and your body affect its look and it affects yours. Footwear should have life with or without the feet, as opposed to clothes that exist only when being worn.'

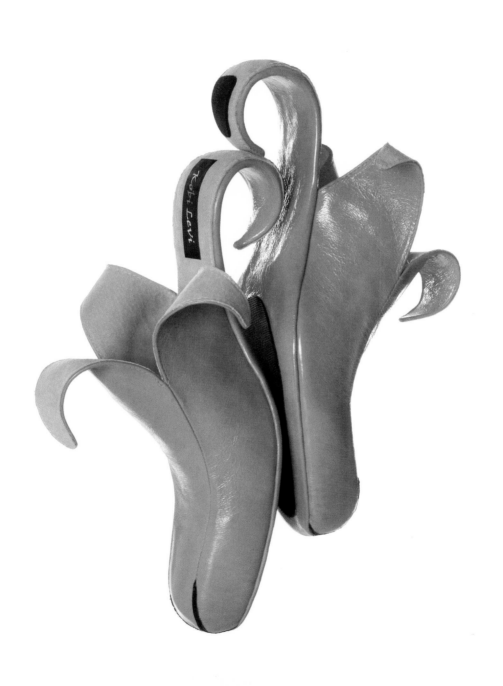

Kobi Levi Banana

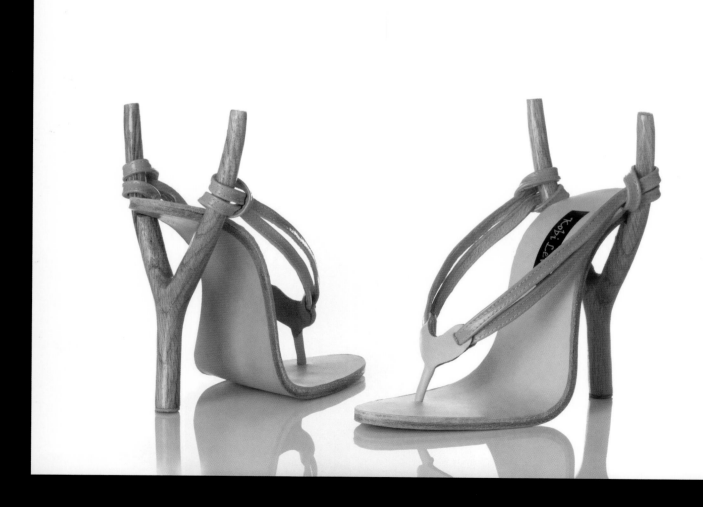

Kobi Levi Sling Shot

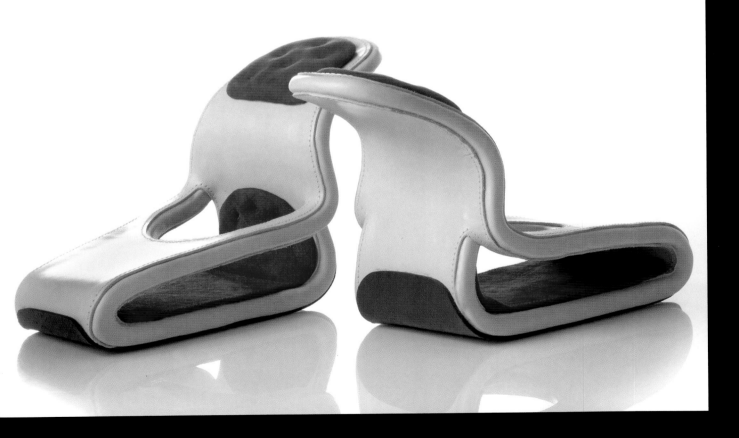

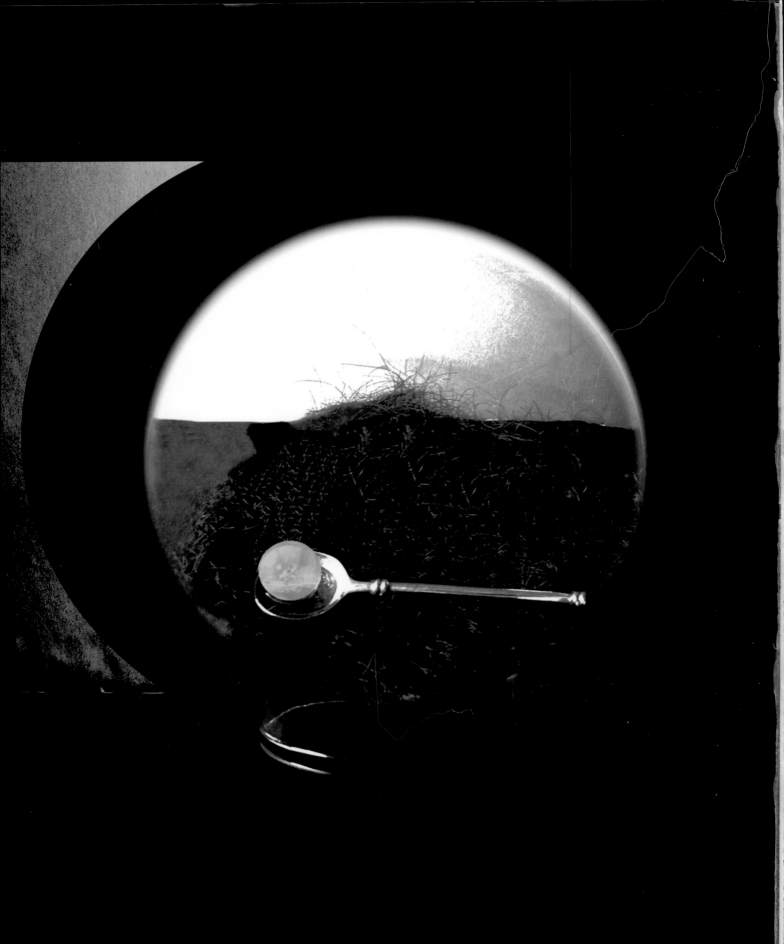

Thank you